7·12

**Friend of
the Library Donor**

LINDA & WES VIETMEIER

2012

© DEMCO, INC. 1990 PRINTED IN U.S.A.

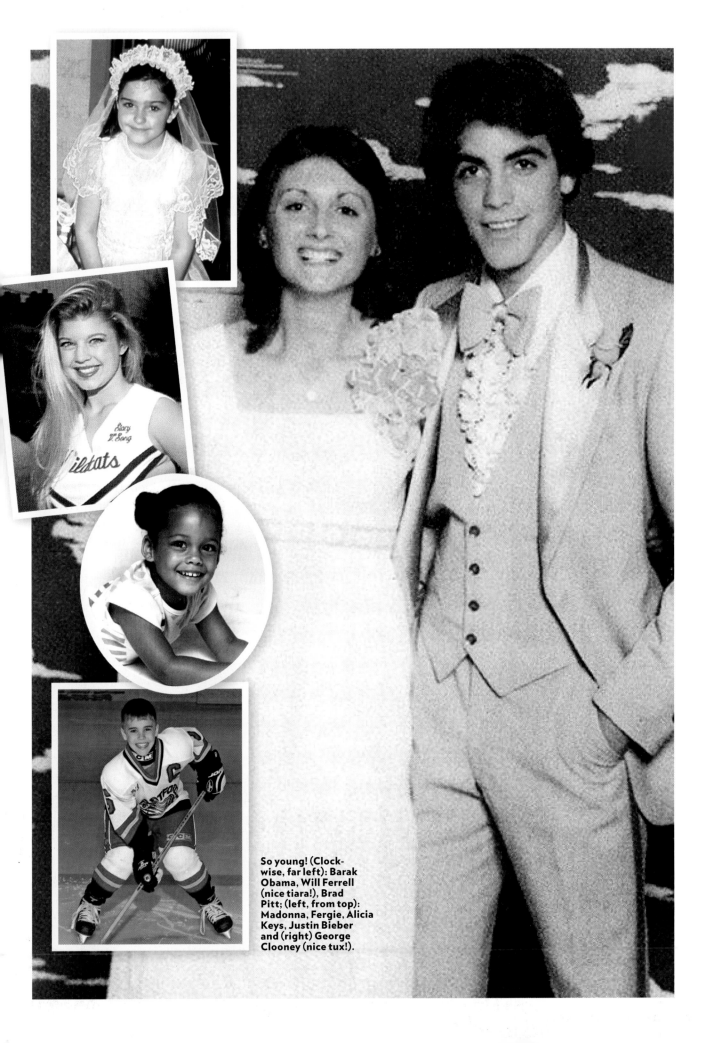

So young! (Clockwise, far left): Barak Obama, Will Ferrell (nice tiara!), Brad Pitt; (left, from top): Madonna, Fergie, Alicia Keys, Justin Bieber and (right) George Clooney (nice tux!).

FIRST
STEPS

Long before
Hollywood called,
they starred
in dance recitals,
school plays,
basketball
tournaments
and teenage
beauty pageants

Nowadays they're Jen, Julia, Angelina, Oprah and Brad, but years ago, when they still needed last names, they went to school, succeeded or flopped at math or the French subjunctive and suffered through awkward phases and '80s hair. Come with us now as we explore the lives of today's hottest celebrities . . .

BEFORE THEY WERE STARS!

CONTENTS

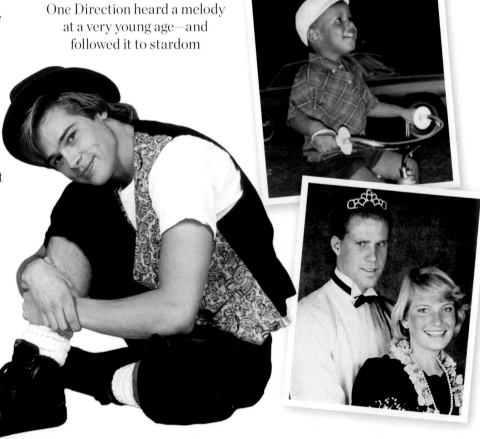

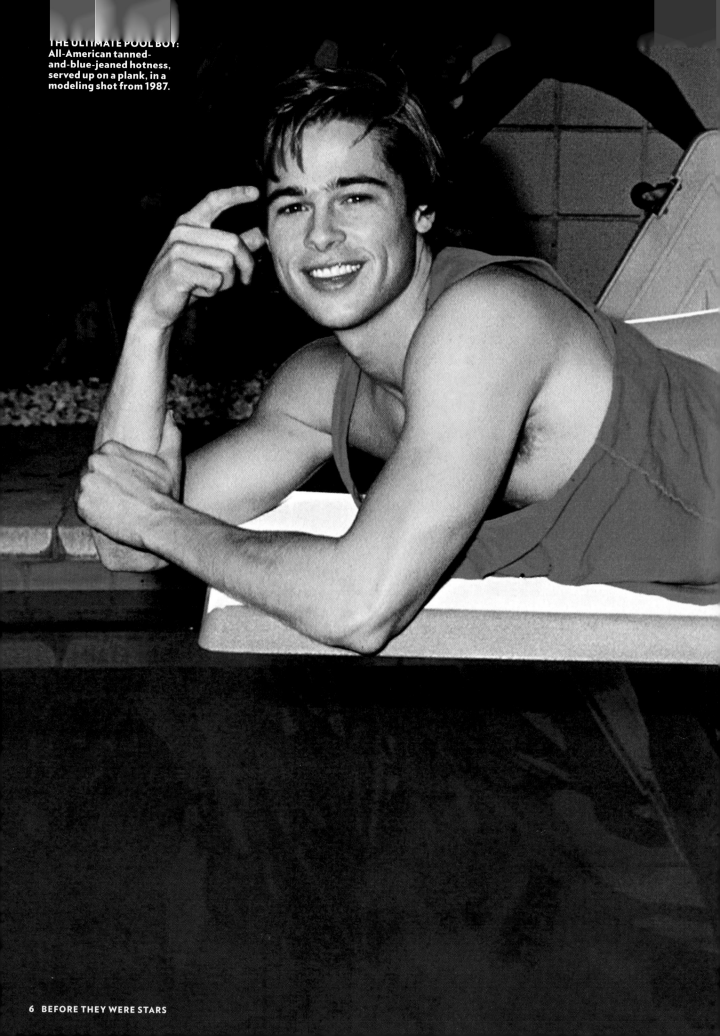

THE ULTIMATE POOL BOY:
All-American tanned-
and-blue-jeaned hotness,
served up on a plank, in a
modeling shot from 1987.

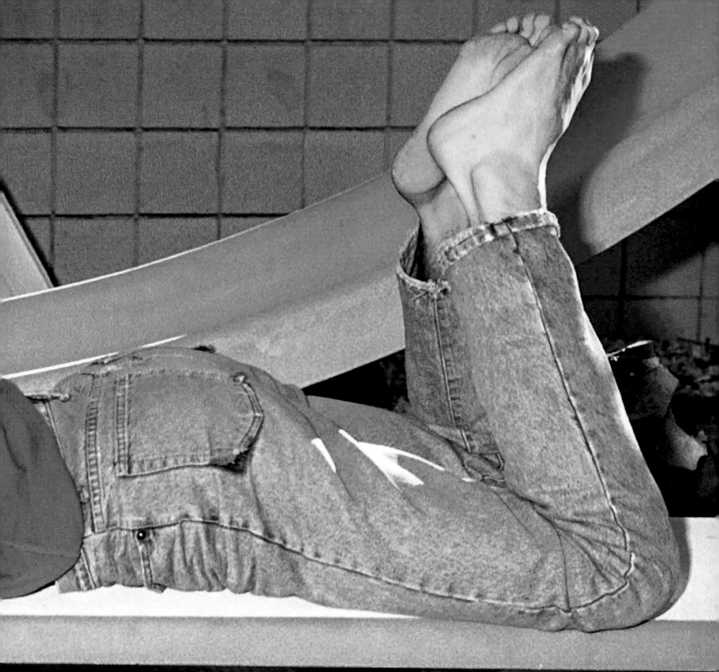

BRAD
PITT

Before Sexiest Man and
Ocean's Eleven, there was just
a kid from Kickapoo High
with a chicken suit and a dream

GOOD STUDENT, WELL GROOMED...
AND HE CAN SING!
TRIPLE THREAT

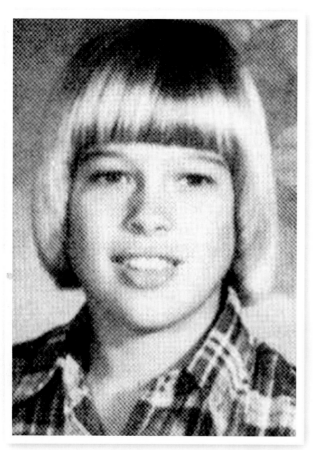

PAGEBOY BRAD:
The face that would someday launch a thousand scripts.

When Geena Davis first laid eyes on William Bradley Pitt in 1991's *Thelma & Louise,* she could hardly catch her breath. Or keep her clothes on. Not all scientists agree that the scene in which a buff, bare-chested Brad strutted out of his Levi's and teased Davis senseless was the actual cause of global warming, but there's no question that it was the beginning of something awfully hot. How hot? A few years later, he earned the first of his twin Sexiest Man Alive titles. "When he looked at me," a Los Angeles waitress said, describing a typical Brad-induced meltdown, "I was worried I would drop his roast chicken and lemonade in his lap."

That was not the first recorded instance of the Brad Effect. Far from it. "You couldn't keep from watching Brad, because his face was so expressive," said Connie Bilyeu, who, as pianist for the South Haven Baptist Church in Springfield, Mo., where 6-year-old Brad sang in the choir, is the earliest known chronicler of the phenomenon. "He would move his little mouth so big with all the words that he attracted everyone's attention."

Just a babe-to-be when he moved from his birthplace in Shawnee, Okla., to Springfield, where his father, Bill, was a trucking-company executive and his mother, Jane, worked as a school counselor, Brad, oldest of the couple's three kids, was a tough act to follow. "Brad was a super kid," recalled an assistant principal at Kickapoo High School, where Pitt excelled in class, participated in student government and even flirted with his inner Elizabethan: He joined Kickapoo's madrigal singers.

No documented cases of inordinate swooning, salivating or eye popping have been attributed to Brad in his high school years. But lucky students at the University of Missouri, where he majored in journalism, were among the first to behold what soon would wow the world when Brad doffed his shirt to pose for a fund-raising calendar featuring a bevy of campus hotties. The reaction seems to have been to Brad's liking: In 1986 he dropped out, two credits short of graduating, and headed for Hollywood. Driving west in a silver Nissan he called

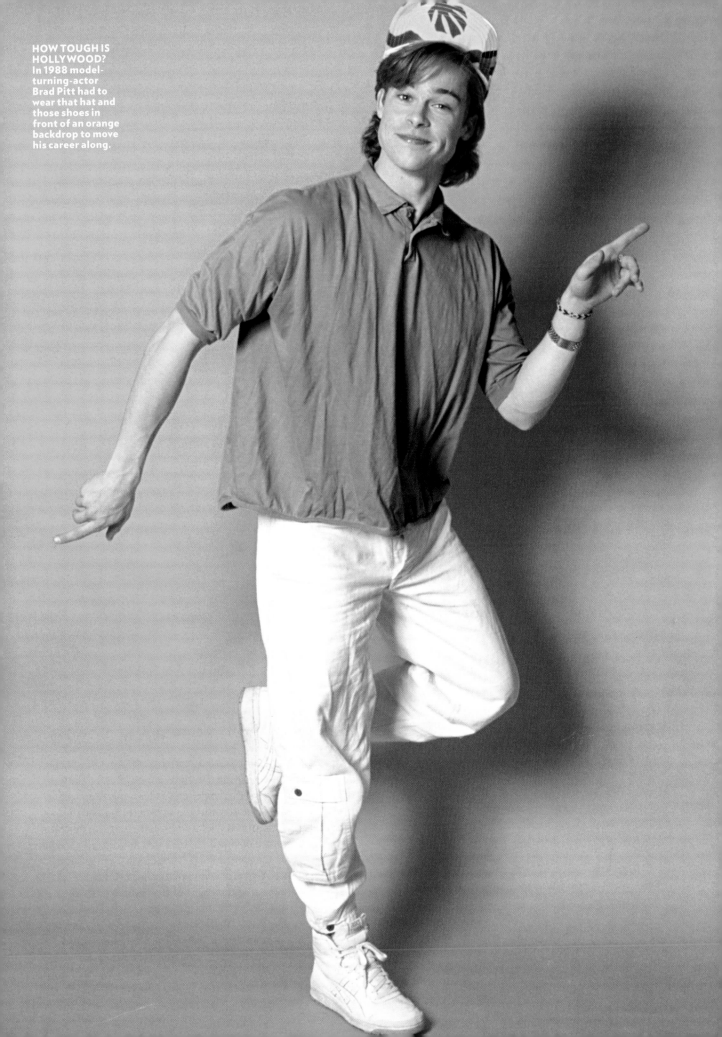

Runaround Sue, Pitt gave himself a year to find an acting job. That meant first donning a chicken suit to shill for a fast-food joint and driving a limo for a strip-o-gram company. Seven months after his arrival, he landed a TV gig and picked up roles on *Dallas* and *21 Jump Street.* Word of the Brad effect began to spread. "He caused such a stir on the set," recalled *thirtysomething* co-creator Ed Zwick. "He was so good-looking and so charismatic and such a sweet guy, everybody knew he was going places."

And rarely alone. Among the magnetized were actresses Juliette Lewis and Robin Givens, who courted the possible ire of her then-estranged husband, heavyweight champ "Iron Mike" Tyson, to experience the Brad effect. As another director explained, "This guy just gets through to women, no matter what."

Forty-eight years in, it shows no signs of stopping.

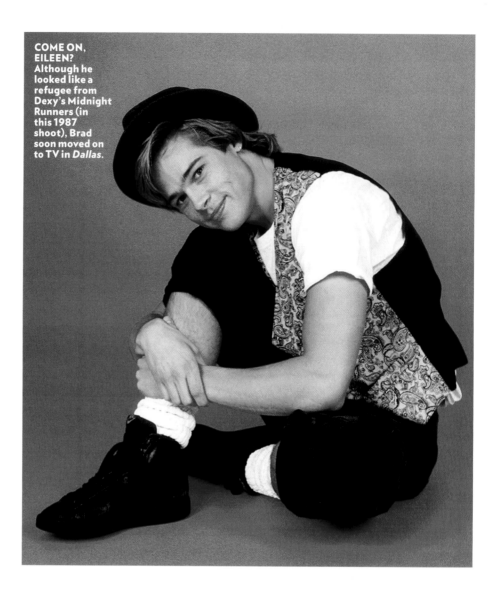

COME ON, EILEEN? Although he looked like a refugee from Dexy's Midnight Runners (in this 1987 shoot), Brad soon moved on to TV in *Dallas*.

THE KICKAPOO YEARS

THE CLOWN

His future was so bright: Brad (left) starred with hipster buddies on Kickapoo High's annual frolic, Sunglasses Day.

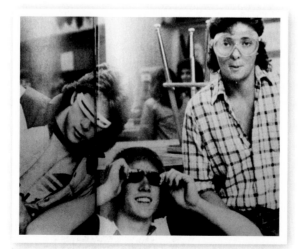

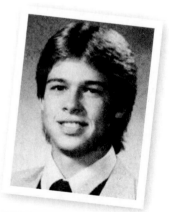

THE JOCK

Brad (getting his Agassi on) was known as a "clean, preppy down-to-earth boy," according to his high school teacher Linda Maggard.

THE CATCH

When Brad later quit college and moved to L.A., he told his parents he was going into graphic design "so they wouldn't worry."

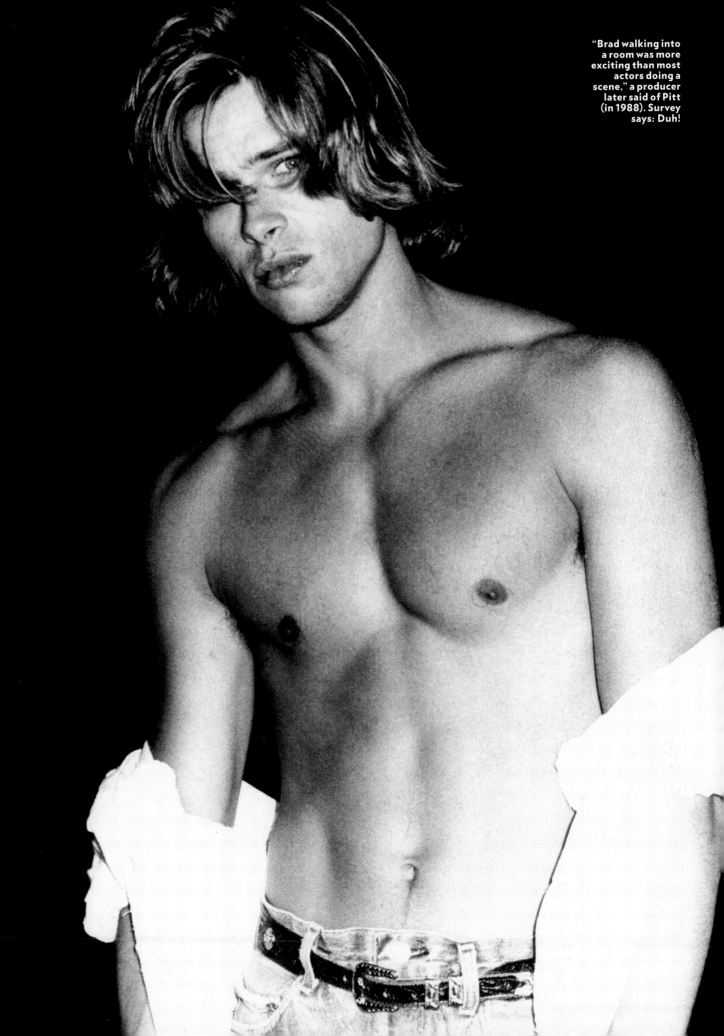

"Brad walking into a room was more exciting than most actors doing a scene," a producer later said of Pitt (in 1988). Survey says: Duh!

Before she slew *The Fame Monster,* she was the good girl next door who adored her parents and always said her prayers— and still does because, well, she was born that way

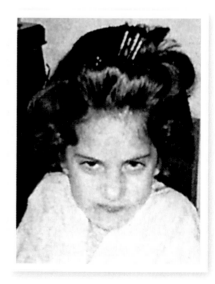

For her first memorable performance she did not don a dress by Holstein or a flame-thrower bra; she didn't even whip up one of her trademark Hello Dali hairdos. "There was a line of 20 girls sitting in a row in our pretty dresses, and we each got up to play," the future Lady Gaga (née Stefani Joanne Angelina Germanotta) recalled of her musical debut, at age 8, in a New York City Convent of the Sacred Heart school piano recital. "I did a really good job. I was quite good."

And so her dreams—and world-conquering confidence—were born. A self-described "nerd-ball" who splurged her after-school earnings on Gucci and got her first tattoo at 15 (later doctored because, she said, "I couldn't face the world with a tramp stamp"), she was "by far the most talented person in high school, but she'd do so many random acts of kindness," recalled a friend. "She wasn't a diva at all."

Germanotta (top, ca. 1996; above, in '04) was a serious student who tried out for school plays to meet boys. Although some envious classmates called her the Germ, "she was popular," a fellow student told *New York* magazine. "I don't remember her experiencing any problems."

LADY

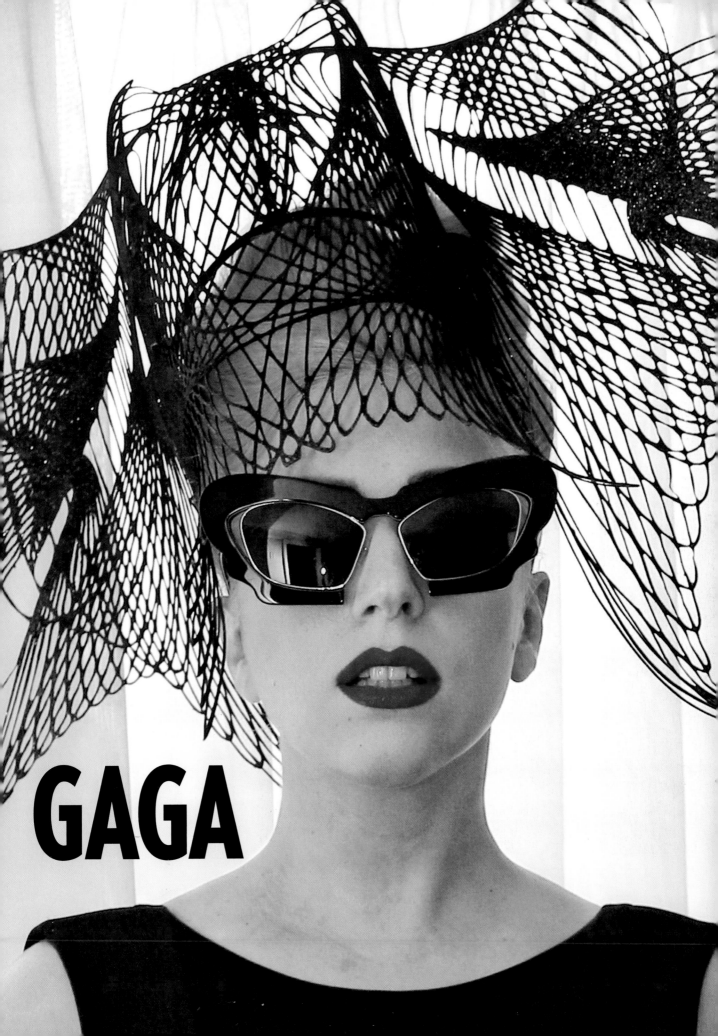

GAGA

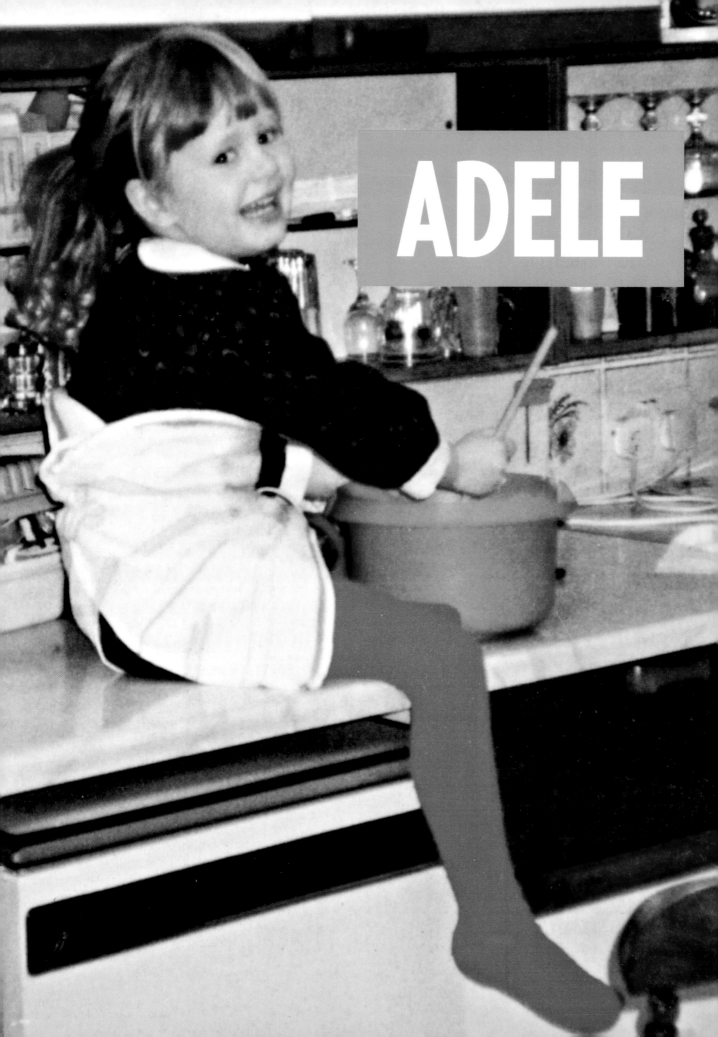

ADELE

Her Pop Highness, Queen of the record charts and ruler of all Grammy surveys, measures her success by the tracks of her tears

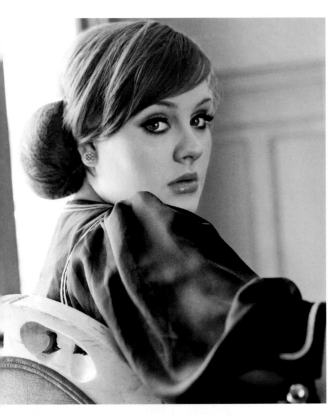

"I know I was a rotten father," Mark Evans (above with Adele in 1999) told PEOPLE. "I was not there for her when I should have been." Now a recovering alcoholic, Evans claims Adele (left, at age 4; inset, at age 3; and today, above) has forgiven him. Not so, she told *Rolling Stone*: "He has no f-----' right to talk about me."

Man trouble began at age 3, when her father walked out on his only child and left her and her mum to fend for themselves in London's hardscrabble and high-crime Tottenham neighborhood. "We've always been on our own," Adele Laurie Blue Adkins, now 24, says of her life with mom Penny, just 18 when her daughter was born. Both found a salve for the loss in old-school emo rock—Adele attended a Cure concert with her mum shortly after her parents split. At 14, the then-passionate Spice Girls fan discovered in Etta James and Ella Fitzgerald the powerhouse style with which her own supple and soulful vocals would later be compared. While blessed with pipes that earned her admission to the BRIT School, London's tuition-free performing arts high school that counts Amy Winehouse among its alumni, she discovered a talent for songwriting that armed her for battle with her curse: a penchant for wrenching romantic heartbreak. Her knack for expressing herself in song, and causing listeners to weep along, enabled her to spin the emotional devastation into platinum with her 2008 debut *19* and last year's Grammy sweeping blockbuster *21*. "I'd never admit the things I write in my songs in conversation," she told PEOPLE. "It's therapeutic to get it all out." And painful as it is to mine her heart for material, Adele isn't giving up on love. Says Adele: "I want to marry Prince Charming."

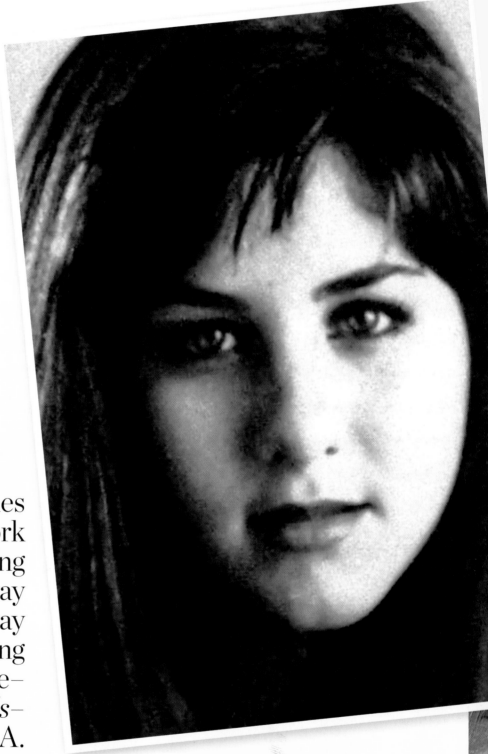

Waiting tables in New York City and playing bit parts way off Broadway kept her going before fame– and *Friends*– arrived in L.A.

JENNIFER

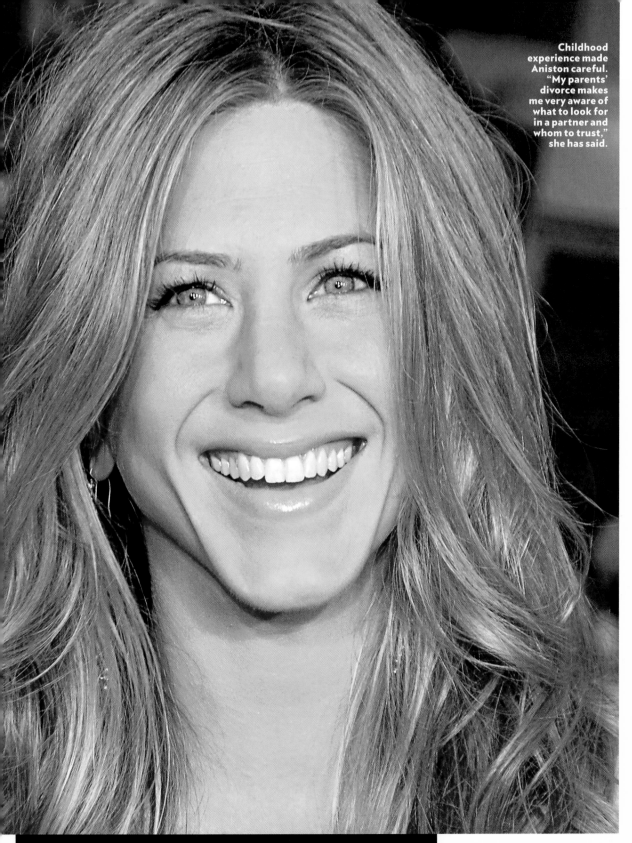

Childhood experience made Aniston careful. "My parents' divorce makes me very aware of what to look for in a partner and whom to trust," she has said.

ANISTON

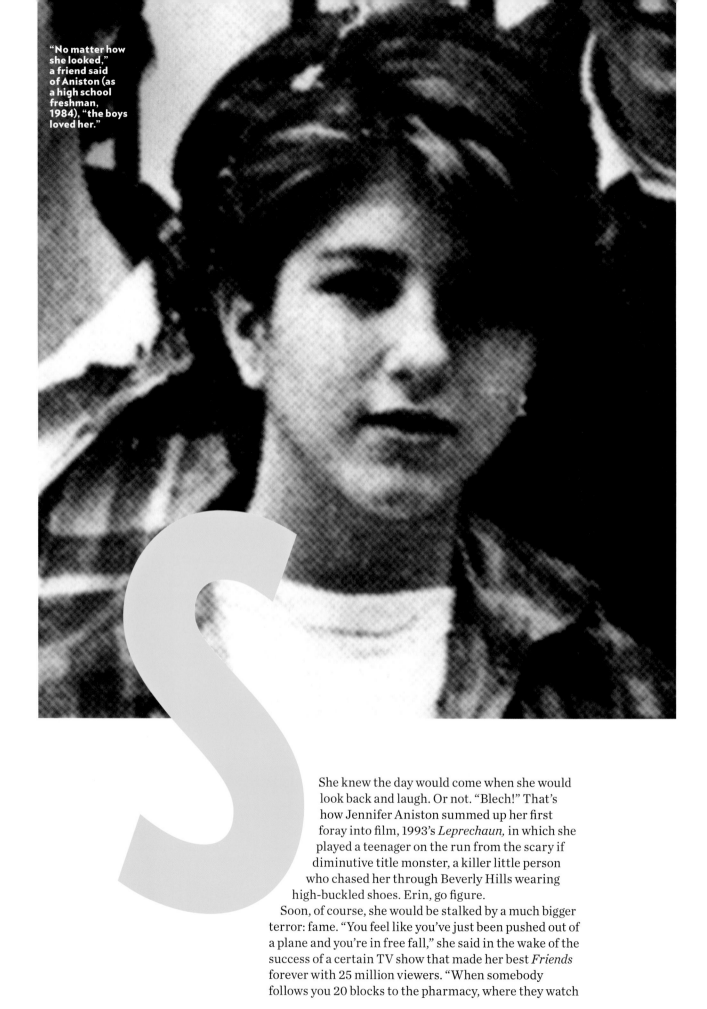

She knew the day would come when she would look back and laugh. Or not. "Blech!" That's how Jennifer Aniston summed up her first foray into film, 1993's *Leprechaun,* in which she played a teenager on the run from the scary if diminutive title monster, a killer little person who chased her through Beverly Hills wearing high-buckled shoes. Erin, go figure.

Soon, of course, she would be stalked by a much bigger terror: fame. "You feel like you've just been pushed out of a plane and you're in free fall," she said in the wake of the success of a certain TV show that made her best *Friends* forever with 25 million viewers. "When somebody follows you 20 blocks to the pharmacy, where they watch

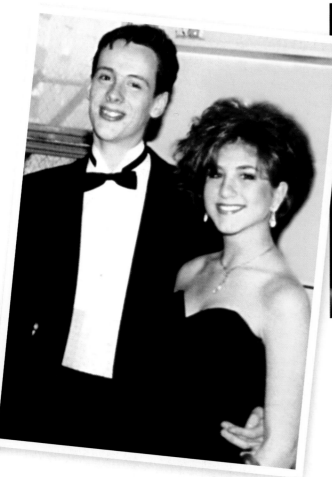

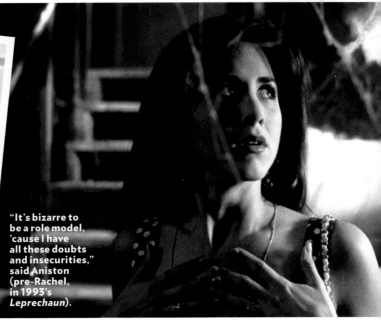

you buy toilet paper, you know life has changed."

Such adulation came as a shock to Aniston, who was accustomed to working in front of a much more demanding audience: her own family. The daughter of soaps journeyman John Aniston, who has played the villainous Victor on *Days of Our Lives* since 1985, and actress Nancy Aniston, Jennifer was once sent to her room without dinner for "not being interesting enough." (*That's* a tough dining room.) Her father, a still-stung Aniston recalled years later, "said, 'Leave the table. You've got nothing to say.' I was doing what young people do: listening and learning. I guess that's the kind of man he is: demandingly blunt."

Born in Sherman Oaks, Calif., she grew up in New York City, where happy memories—her godfather, Telly Savalas of *Kojak* fame, lavished her with presents ("I'd get bicycles and lollipops in the mail," she recalled)— were overshadowed by the sadness that descended with her parents' divorce. Nine at the time, she felt buffeted by what she described as almost constant family feuding. "I come from a fighting family, and I had a tough time arguing," she said. "Fighting scared me. I wouldn't speak up for myself."

She found other ways of expressing her feelings. "I chopped [my hair] off and dyed what was left black," she recalled. "I walked around with tons of liquid eyeliner on. My mother went into cardiac arrest every time she saw me." Another act of rebellion proved more productive: Over her father's objections, she announced

at 11 that she intended to become an actress. "He gave me all the usual reasons," she said of her father's grave warnings. "'You don't want to deal with rejection.' 'It's competitive.' 'You can't always count on steady income.' It was almost like making sure I was going to do it."

After graduating from New York City's Fiorello H. LaGuardia High School of Music and Art and Performing Arts, she waited tables, worked as a telemarketer and sold time-shares to pay the rent while making audition rounds. "I never thought I would truly make it, considering my acting teachers were always telling me that I'm a disgrace to the theater!" she later recalled with a laugh. "In the two years that I lived in New York after school, I got maybe two jobs: a Bob's Big Boy commercial, then a part in a play, off-off-off-Broadway."

Moving west to try her luck in Hollywood in 1990, she survived *Leprechaun,* failed TV fare (*The Edge*) and shed 30 lbs. "I was the most unhealthy person," she recalled. "I lived on cheeseburgers and fries and mayonnaise." Kicking junk food, she landed the role of spunky, spoiled Rachel Green in a pilot titled *The One Where It All Began.* The show appealed, she said, because it "captures that lost period in your 20s when you don't know where you're going or what you're doing or who you are." Originally tapped to play Monica, the role that went to Courteney Cox, she persuaded producers to cast her as Rachel because "she was quirkier."

And she had better hair. But the woman who inspired the look of the '90s with her famous blunt cut discouraged fans from doing the "Rachel." "When I was in high school, I tried to copy Valerie Bertinelli's hairdo," she said. "It was a total disaster. I would spend each night desperately wrapping my bangs in pink curlers from my Barbie play set. I'd take out the curlers in the morning, and the hair would slide into what looked like two little sausages. This is why you should never copy a celebrity do!" Take it from a Friend.

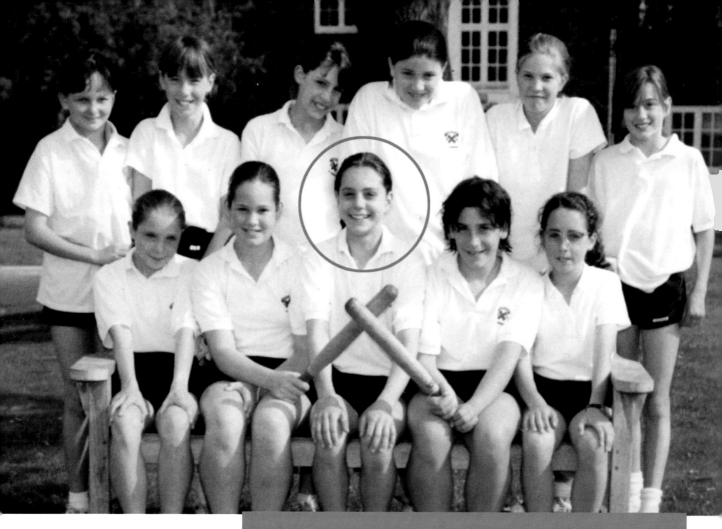

KATE MIDDLETON

The commoner Princess Bride was not always the picture of royal poise and pluck—but no snogging please

She wasn't really confident," a boarding school classmate recalled of first impressions made by the shy and awkward teen. "The poor girl, we felt sorry for her." The oldest child of a former airline dispatcher and flight attendant turned mail-order magnates, Catherine Elizabeth Middleton was bullied in school but blossomed late—and spectacularly. In classrooms and on the playing fields of the exclusive schools she attended before enrolling at the University of St. Andrews in Scotland—where she would meet a certain charming prince—the uncommonly talented commoner was good in math, sciences and the arts; led her schools' tennis, hockey, swimming, netball and rounders teams; starred in theatrical productions; danced ballet and tap and was an outstanding orchestra flautist and singer. And, friends recalled, she had other talents as well. "Everything looked good on her because she had such a perfect body," a former classmate told PEOPLE. Even so, "she wasn't one for the random snog [kiss]. She didn't need a guy to be happy." That said, she seems happy with the one she found.

IN SCHOOL, A TEAM PLAYER

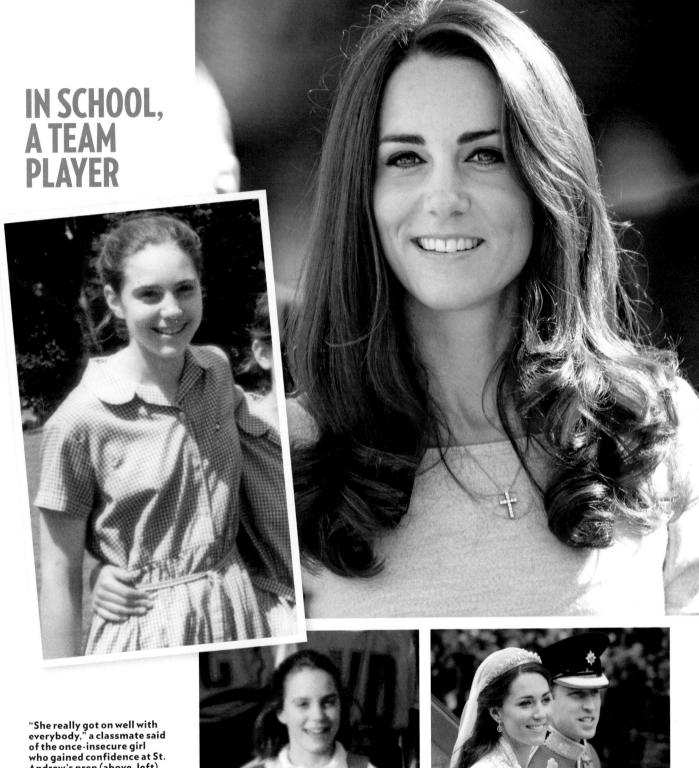

"She really got on well with everybody," a classmate said of the once-insecure girl who gained confidence at St. Andrew's prep (above, left), the boarding school she attended from ages 7 to 13. She starred in rounders (the Brit version of baseball, opposite) and netball (basketball, right). "She was a really lovely, warm girl who didn't have a bad bone in her body," a classmate said. "It's still hard to imagine her becoming Queen one day, but I can tell you one thing—if she does, the royals will be lucky to have her." Far right: William and Kate on their wedding day.

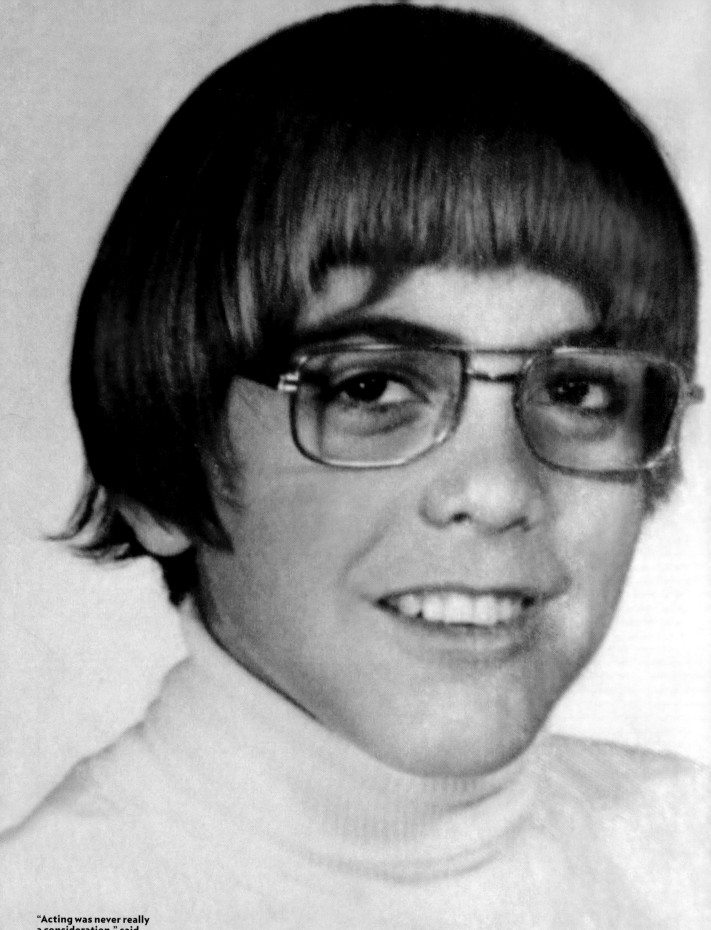

"Acting was never really a consideration," said Clooney (in an undated family photo), whose boyhood ambition was to play center field for the Cincinnati Reds.

GEORGE CLOONEY

Now he makes fine films and *Oceans* of dough, but the suavest leading man alive played in his share of turkeys and *Tomatoes*

HIS OLD KENTUCKY HOME HAD A LINK TO HOLLYWOOD

Growing up on the set of his father's Cincinnati talk show, George Clooney loved meeting the celebrity guests and learning his way around a TV studio. But it wasn't until he worked as a driver for his aunt, big-band singer Rosemary Clooney, and her touring road troupe that he learned, as she used to sing, there really is no business like show business. "There was nothing sweet and subtle about driving those broads around," Clooney recalled fondly after his aunt died in 2002. "In the backseat Martha Rae would shout, 'Georgie, pull the car over; I have to take a leak.' Then she'd hang a leg out the window and do her stuff while I kept looking forward. Meanwhile my Aunt Rosemary would say, 'Honey, don't turn around. You'll learn too much about the aging process.'"

Oy, oy, oy: so much for the glamorous life of stars. But now that Clooney has long since joined the ranks of Hollywood's elite himself, it's hard to imagine that it took the suave, cool and connected actor half his professional life to get there. Even when his career was in deep depression—*Return to Horror High*, in 1987, and

1988's *Return of the Killer Tomatoes* vie for his filmmaking nadir—Clooney was buoyed by the same disarming charm and dash that a decade later made him PEOPLE's Sexiest Man Alive. "I wasn't going to bring that one up, thanks a lot," he said when asked about *Tomatoes*. "Hell, I still made $100,000 that year, and that's a great living, even if you're being attacked by large vegetables."

The son of a Miss Kentucky runner-up and a popular local TV personality whose sister Rosemary and brother-in-law José Ferrer made Hollywood seem a not-too-distant dream, Clooney grew up in tiny Augusta, Ky. His childhood was both typical—he played basketball and baseball and fantasized about becoming a pro athlete—and far from it. His father, Nick, cast him in on-air skits from the age of 6, and both George and his older sister Ada were expected to entertain guests at their parents' frequent house parties. When cousin Miguel Ferrer came to town to shoot a never-released film about horse racing in 1982, he cast George in a small part and set him on his career course. "It was a cheesy, awful film," Clooney remembered, "but

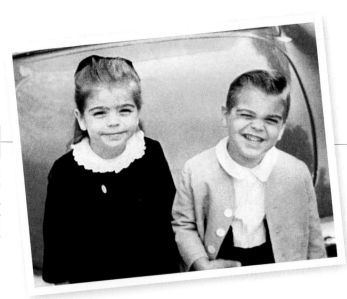

CUTIE

RIGHT BACK ATCHA: Even as a tyke, Clooney (with sister Ada) looked ready for anything.

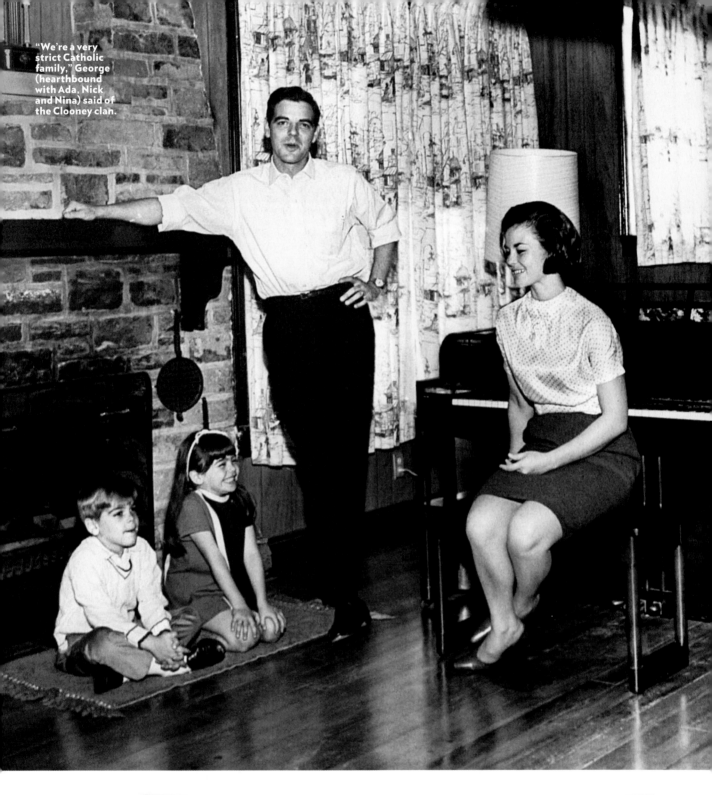

"We're a very strict Catholic family," George (hearthbound with Ada, Nick and Nina) said of the Clooney clan.

HAIRY

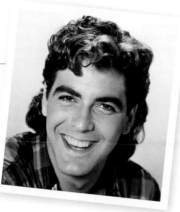

MULLET MAN: "I didn't take school seriously," he said of a brief college career.

FUNNY

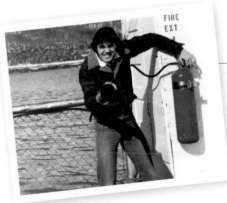

MERRY PRANKSTER: Early on, Clooney honed his skills as a practical joker.

George (right) specialized in Nat King Cole impressions, but he was game for corn as well.

GEORGE'S NOT-SO-HOT SHOWBIZ MOMENTS

'84 *E/R* Ten years before he hit the big time in NBC's *ER*, Clooney landed with a thud in this CBS emergency-room comedy.

'85 *Street Hawk* Clooney appeared as a sidekick in Rex Smith's renegade-cop show. The series lasted 13 episodes.

'86 *Combat Academy* High jinx at a military academy; George makes his film debut as Maj. Biff Woods.

'87 *Return to Horror High* "Okay, you got me, I'm a hack," Clooney said to anyone accusing him of hauling trash.

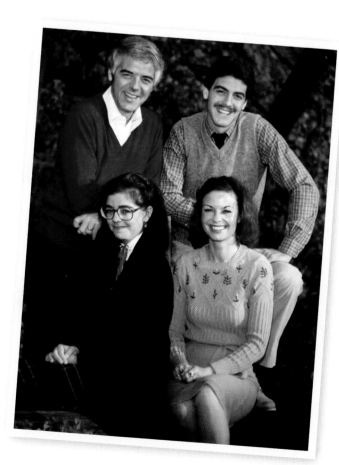

Not "a lot of Kentucky families voted for McGovern," George said of the proudly liberal Clooneys.

I was seduced by how attractive it was. It was something I really felt I could do."

Quitting college, where he had studied broadcasting—"I wasn't nearly as good as my father," he said—Clooney earned $450 on a tobacco farm, enough to finance a two-day drive to the coast in a beat-up Monte Carlo with a faulty ignition. "I left it running and slept on the side of the road for an hour and then kept going," he said. "I drove it all the way across the country until it sputtered into Beverly Hills." There he lived with Aunt Rosemary, served as

her chauffeur, rode a 10-speed to auditions and conned his way into meetings. "I didn't have an agent," he said, "so I would call and pretend to be an agent." He quickly landed his first acting job, in a Japanese TV commercial. For the next 12 years, Clooney worked steadily but on the fringes of success. The stardust drought ended in 1994, when he was cast as Doug Ross, lothario in a lab coat, in *ER*. "The funny thing is, I never gave up," he said. "Even when things weren't great and I was doing *Sunset Beat* or *Baby Talk* on TV, I still felt like a winner."

'90 *Sunset Beat* Cop by day! Rocker at night! This TV movie gave Clooney his best-ever character name: Chic Chesbro.

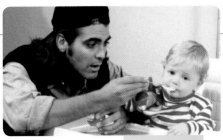

'90 *Knights of the Kitchen Table* "If you're making a living," Clooney philosophized, "you're doing good." The pilot never aired.

'91 *Baby Talk* Clooney is upstaged by a chatty infant in a knockoff of *Look Who's Talking*. Scott Baio costarred!

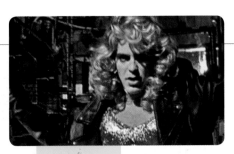

'92 *The Harvest* Clooney played a nameless "lip-synching transvestite." Viewers found it a drag.

'93 *The Building* Clooney played Bonnie Hunt's fiancé. A flop from David Letterman's company.

Thank you, Farrah? The *Pretty Woman* star got her start acting out *Charlie's Angels* in front of a mirror

JULIA ROBERTS

"My childhood was real weird to me," Julia once said. "I feel like I grew up twice. Once till I was about 10. My father died around then."

W

When Julia Roberts graduated from Campbell High School in Smyrna, Ga., in 1985, she didn't see limitless possibilities stretching before her. "I had convinced myself that I had three choices," she said later. "I could get married, I could go to college or I could move to New York. Nobody was asking to get married, and I didn't want to go away to school, so I moved." But not before she asked her mom. "She was like, 'I love you. Go. Do it. Eat your vegetables.'"

So the 17-year-old aspiring actress packed her car and joined the endless migration of hopefuls to Mecca. Like all who make the trek, Julia had her follow-that-dream mantra: "I drove to New York saying to myself, 'Something's up there.'" Apparently there was: Five years after she arrived, Roberts won raves as the sweetheart hooker-next-door in *Pretty Woman*, the unlikely Cinderella story that grossed more than $175 million and made her a superstar. A blockbuster or two later, she became the highest-paid actress alive. For fans it was infatuation at first sight. Beauty and bankability aside, she bloomed into something even more rare: a beloved cultural icon whose charms didn't fade when the lights went up. Asked during the hoopla over *Pretty Woman* if it was embarrassing to be tagged with the title, she flashed her worldwide smile and drawled, "Beats being called 'Mediocre Gal,' you know what I mean?"

Spoken with the pluck and aplomb of a natural. But it didn't always come easily for Roberts. Her life seemed blessed at first. Her drama-coach parents were running an actors' workshop when her mother, Betty, was pregnant with Julia in 1967. Among the students were the children of the Rev. Martin Luther King Jr., who would be assassinated in Memphis the next year, and

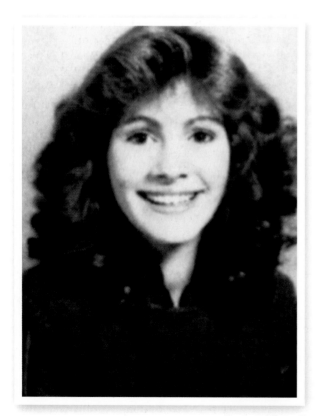

"I gotta tell you," said Julia (in her 1984 high school yearbook), "higher education wasn't for me."

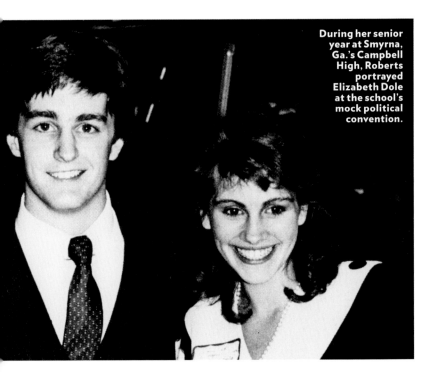

During her senior year at Smyrna, Ga.'s Campbell High, Roberts portrayed Elizabeth Dole at the school's mock political convention.

Her turn as the pizza-joint drama queen in *Mystic Pizza* "shows a priceless movie quality: a real sense of danger and unpredictability," said the *Los Angeles Times*.

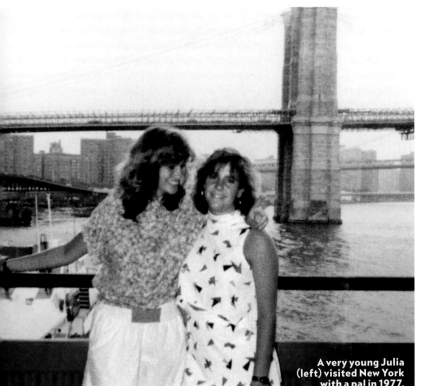

A very young Julia (left) visited New York with a pal in 1977.

Lisa also became an actress. Older brother Eric was already an established star when Julia was in high school. "I wanted to be an actor ever since I was a little girl," she said, "but it took me a long time—when I was 14 or 15—to confess it to anybody. That meant a lot of acting out *Charlie's Angels* alone in front of a mirror."

Like most high schoolers, Roberts was mesmerized by what the future held. She and her best friend would "have tuna sandwiches and Diet Coke, watch soap operas and talk about what we wanted to do with our lives when school was over."

By graduation Julia knew. And when she arrived in New York, she quickly got a leg up on many of the table-waiting masses. A job selling running shoes came in handy when she needed to sprint to auditions during lunch breaks. And a friend of a girlfriend of her brother Eric's had a friend: "She was an agent. Next day she called."

In just three years, Julia gained notice in *Mystic Pizza,* the winning 1988 drama that set the stage for stardom. "I want to get married and have kids and the whole shebang," she said in the wake of *Pizza*'s success. "That's far off in the future, though. But yeah, I'd love to have a place with horses and kids running around with dirt on their faces. I'd like that. Someday."

Someday, of course, arrived: Along with homes in New York and Los Angeles, Roberts and her husband, cameraman Danny Moder, 43, now parents to twins Hazel and Phinnaeus, 7, and Henry, 5, own a ranch in New Mexico.

his wife, Coretta. When Julia (she was christened Julie) was born, Coretta paid the Robertses' hospital bills.

Soon "it all seemed to fall apart," Julia said of her parents, who split up in 1971, after 16 years together. "They were kind of defeated."

Even so, before her father, Walter Roberts, died young, at 47, of cancer when Julia was 9 ("That changed me more than I realized," she said. "It was a rough time"), he and Betty passed on their love of their craft to their children. "They taught me that when it's your heart and soul, it's worth it," says Julia, whose sister

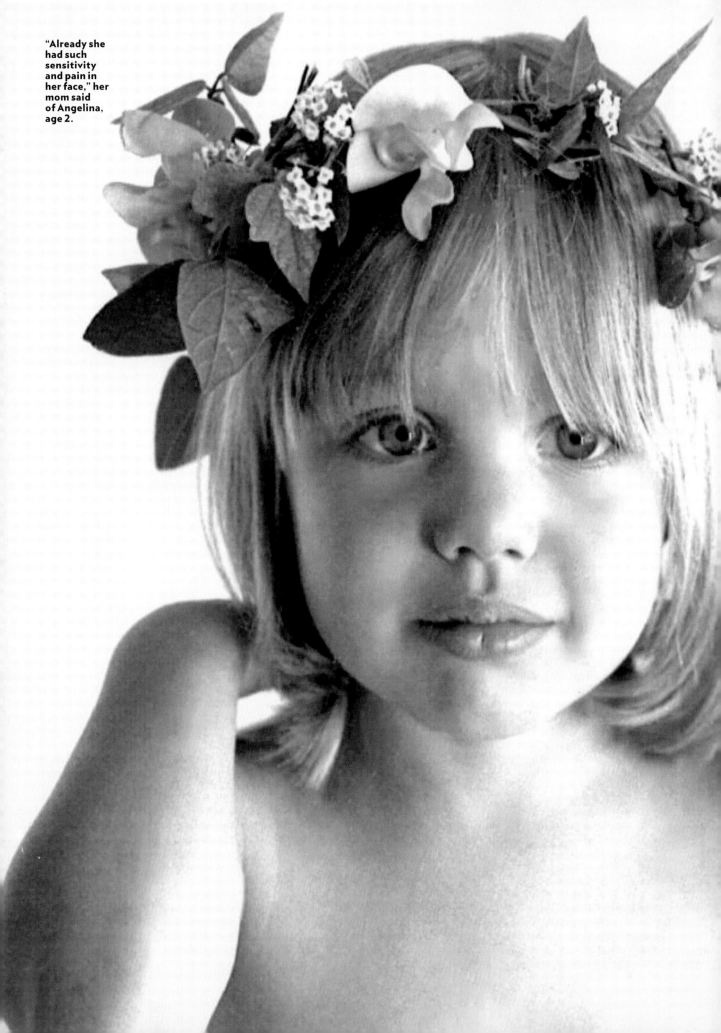

"Already she had such sensitivity and pain in her face," her mom said of Angelina, age 2.

ANGELINA
JOLIE

In grade school
she liked to wear a
'black velvet frilly
little showgirl'
dress and kissed
the boys until 'they
would scream'

Angelina Jolie "is wearing black leather pants, a white T-shirt with nothing written on it in blood and black sandals," journalist Mim Udovich wrote in a 1999 profile. "She has very long, graceful monkey toes that almost look like fingers, and if she were not an actress and a bombshell she could easily make a living having them worshipped."

Is that any way to talk about a soon-to-be Academy Award winner? Then again, Hollywood has never seen one quite like Jolie, an actress who, early on, promoted her films by showing off her most intimately placed tattoos to reporters and talking freely about her sexual appetites, her childhood desire to become a funeral director and her lifelong fascination with knives and blood. Then, in a few short years, she would execute one of the most stunning image transformations in Hollywood history, morphing from an alluring wild child into a United Nations goodwill ambassador, philanthropist and globe-trotting earth mother of six, including three children adopted in Cambodia, Ethiopia and Vietnam. It's surprising to recall the days when the doting mother of Maddox, Zahara and Shiloh, Pax, Knox, and Vivienne cultivated a somewhat less wholesome public image. As Udovich recalled, at Jolie's first wedding, in 1996, the 20-year-old bride wore black rubber pants and a white shirt with the name of her beloved, *Hackers* costar Jonny Lee Miller, scrawled across it in her own blood. "It was no more shocking," she told another reporter, "than promising your life to someone."

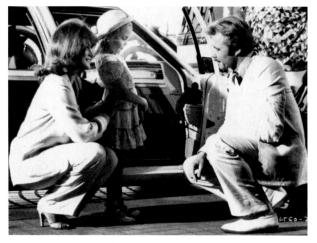

Good as they looked in genes, "there was a lot of hurt and anger" between Angelina and her father, actor Jon Voight (in *Lookin' to Get Out* with Ann-Margret and Angelina in 1982) said of the effect of his divorce. Jolie and Voight had been estranged since 2002, when he made a public appeal for her to seek help for "serious mental problems," but they reconciled seven years later.

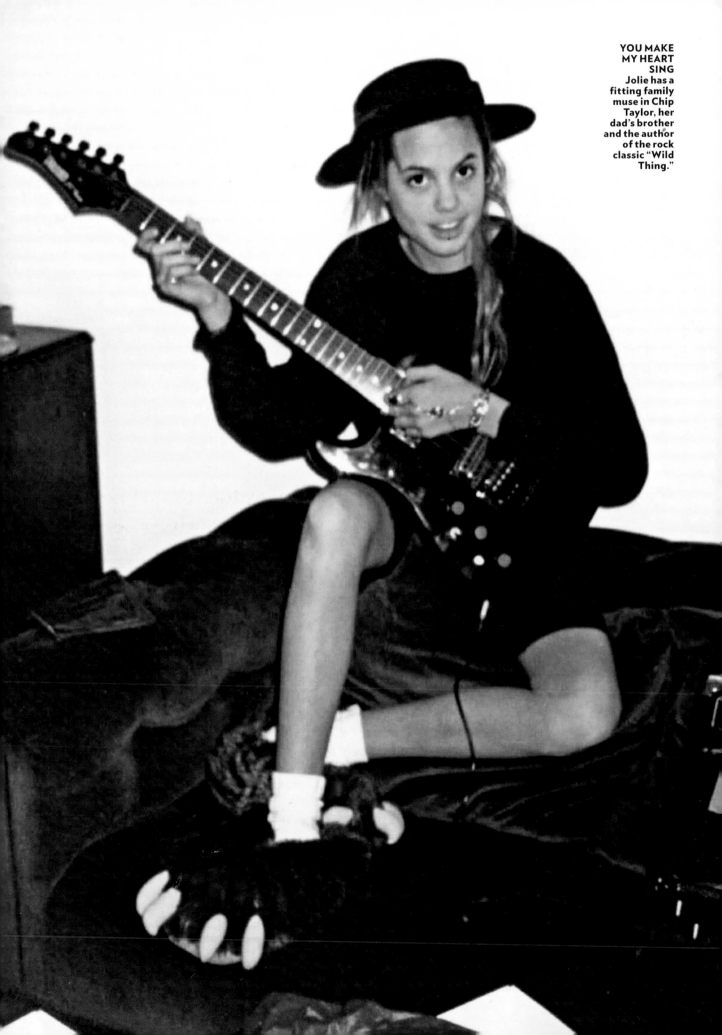

Prep work for stardom began at birth, when her parents, Oscar-winner Jon Voight and former actress Marcheline Bertrand, bestowed upon Angelina (Italian for "little angel") Jolie (French for "pretty") Voight a built-in stage name. But their 1978 divorce caused a lifetime of bitterness. "I grew up with my mum and my brother," she said of life without father. "There are pictures of me with him because his bits of time with me tended to be in front of the press." Ouch. Acting—and acting out—dominated her life from early on. At 5, she debuted with Dad in Hal Ashby's *Lookin' to Get Out,* and studied in a preteen actors workshop. In grade school she chased boys—literally, she said, and kissed them until "they would scream"—and liked to wear a "black velvet frilly little showgirl thing with sparkles on my butt, and I used to love those plastic high heels!"

Soon, she said, "I had gotten really into leather." At 16, she graduated from Beverly Hills High and got her own apartment. Small stage parts and on-the-job training in 1993's *Cyborg 2* won her notice. "You can't not look at her," one producer said. "I gasped when I met her," said a director. "I just thought she was breathtakingly beautiful."

So did her leading men. "I always fall in love while I'm working on a film," Jolie—who has wed two costars (Miller and *Pushing Tin*'s Billy Bob Thornton) and met her man-of-seven-years, Brad Pitt, while filming *Mr. & Mrs. Smith*—said in 1999. Once filming's over, she added, "you slip out of it like a snakeskin, and you're cold and alone." Don't fret, Brad. That was then; she's the new Angelina now.

OH, BROTHER

Like his little sister, James Haven Voight traded the family name for early anonymity. Haven, 38, who also was raised by their mother with sporadic support and attention from their father, memorably stepped into the spotlight when he joined Angelina for a sib lip-lock at the 2000 Oscars (right). "What they accused us of was a disgusting thing," Jolie said of ensuing chatter.

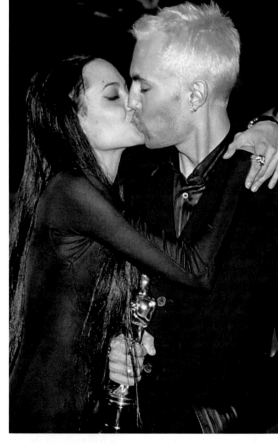

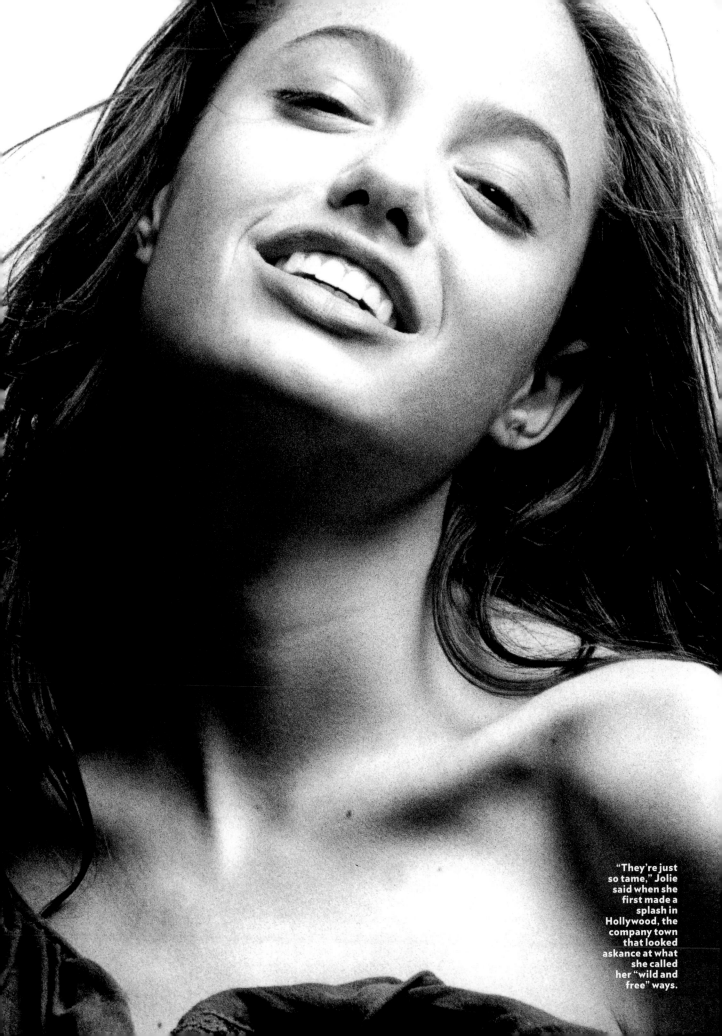

"They're just so tame," Jolie said when she first made a splash in Hollywood, the company town that looked askance at what she called her "wild and free" ways.

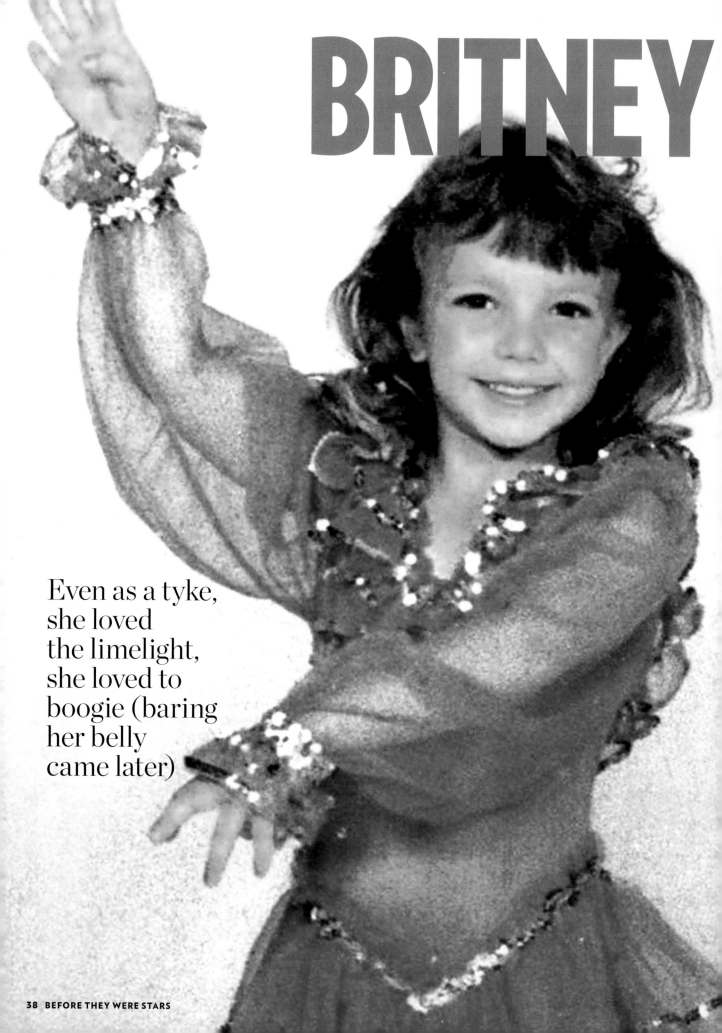

BRITNEY

Even as a tyke, she loved the limelight, she loved to boogie (baring her belly came later)

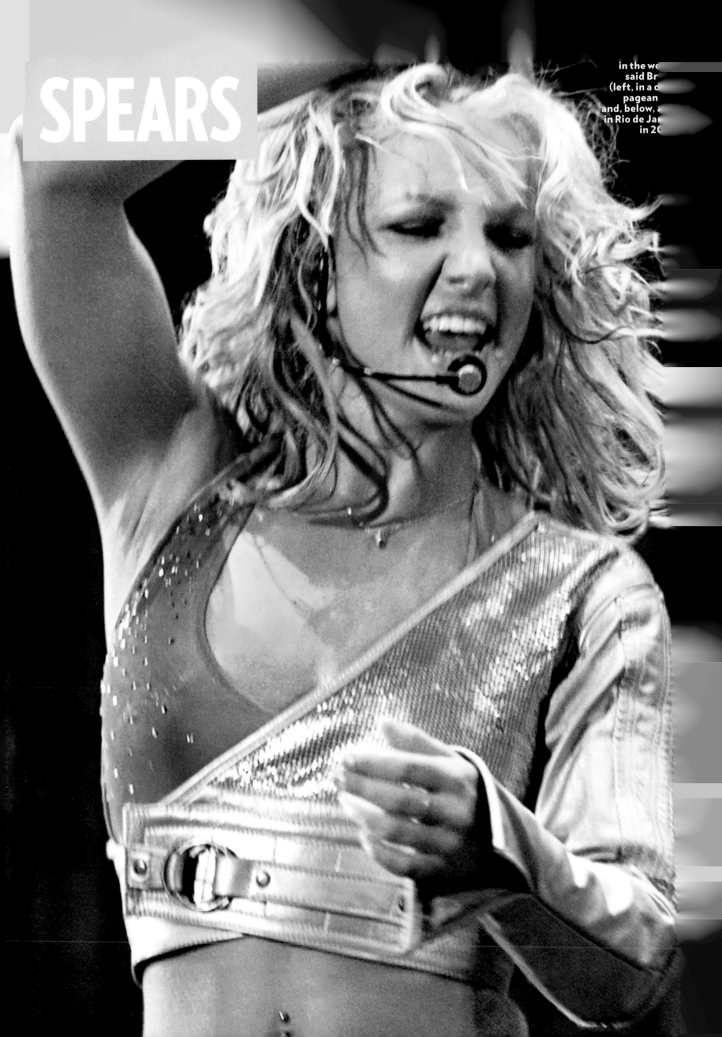

SPEARS

in the wo
said Br
(left, in a c
pagean
and, below, a
in Rio de Jar
in 20

THERE'S NO OOPS! ABOUT IT

Look! There are no paparazzi, no tabloid headlines, no shocking photos and no questionable beaux hovering nearby.

Britney Spears must be dreaming, right? Actually, no: It's 1986, and little Brit-Brit is 5 years old and making her stage debut in kindergarten, warbling the Christmas hymn "What Child Is This?" Recalled her big brother Bryan years later: "She was always performing and belting out these songs. I'd yell at her to shut up because I couldn't hear the TV."

Soon he wouldn't be able to walk by a set without seeing his sister, the video vixen destined to be the biggest teen solo act in pop history. By 19, she would sell more than 22 million copies of her first two albums (1999's . . . Baby One More Time and Oops! . . . I Did It Again, in 2000). But long before she became extravagantly wealthy and almost painfully famous

she was already grabbing the spotlight. "Even as a little baby, she was really darling," said her mom, Lynne. "She has always been noticed."

The middle of three children born to Lynne, a former schoolteacher, and building contractor Jamie Spears, Brit-Brit, as everyone called the precocious kid in Kentwood, La., north of New Orleans, was annoying her brother at an early age. "She would put on makeup and sing to herself in the bathroom mirror," Bryan told PEOPLE in 1999. Even Britney admitted, "I would get on my mom's nerves."

To channel her energies—and, perhaps, get her out of the family's three-bedroom ranch house —Lynne ferried her to dance lessons, talent shows and gymnastics events. But Britney—who passed the driving time singing the radio hits of Madonna, Mariah Carey and Whitney Houston, stars she

The future Mouseketeer posed with Minnie during a visit to Disney World.

Long before she tarted up the pop charts, button-cute Brit (at 7) oozed stage presence.

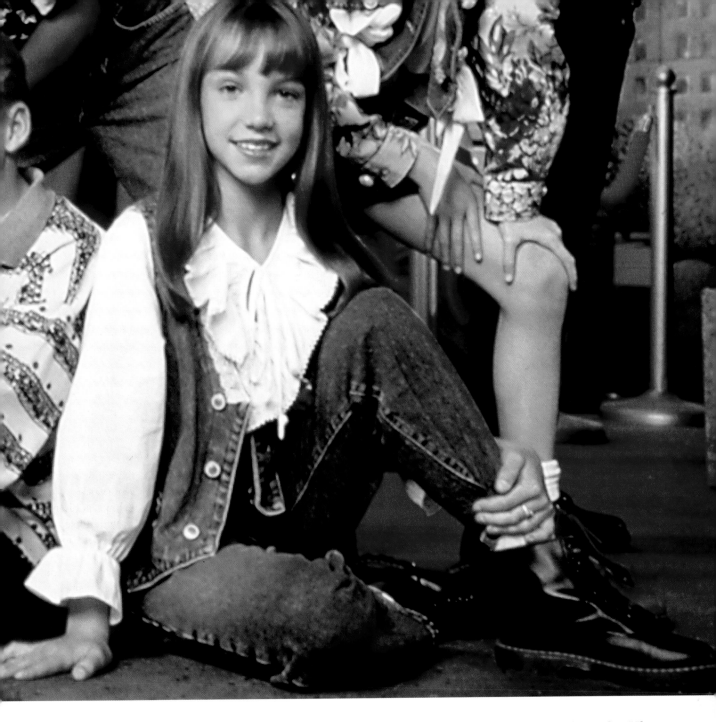

would one day rival—began to look beyond the confines of Kentwood.

As an 8-year-old, Britney auditioned for the Disney Channel's *Mickey Mouse Club* but was deemed too young. A casting director was impressed enough, however, to recommend her to a talent agent, who in turn helped her land a gig as understudy to another teen with a stellar future, Natalie Portman, in an Off-Broadway play, an appearance on *Star Search* (she lost in the second round) and eventually another shot at becoming a Mouseketeer. "It was like a dream come true!" the then 11-year-old told New Orleans's *Times-Picayune* in 1993, after she beat out 15,000 hopefuls. In 1994, when the show was canceled, she returned to Kentwood to lick her wounds. "I did the homecoming thing and the prom thing," she said of two desk-bound years in high school. "I was totally bored."

Not for long. A 1997 audition at Jive Records—"She blew us away," one exec said—won her a contract at 15, and she recorded . . . *Baby One More Time* the following year. Although Britney liked to say she was too busy for serious romance and vowed to protect her virginity until marriage—"I don't want to be bad and do crazy things," she said—when it came time to shoot the video for the title track, she vamped unlike a virgin in a schoolgirl's mini and bare midriff. "Lolita on aerobics," Camille Paglia quipped when the video ignited a frenzy. Britney said it was just good girlish fun. "The outfits looked kind of dorky, so I was like, 'Let's tie up our shirts and be cute.' It was about being a girl and knowing about fashion."

And enjoying the results. "It's so awesome just to hear your song on the radio and see your video on MTV," she gushed. "This is unreal."

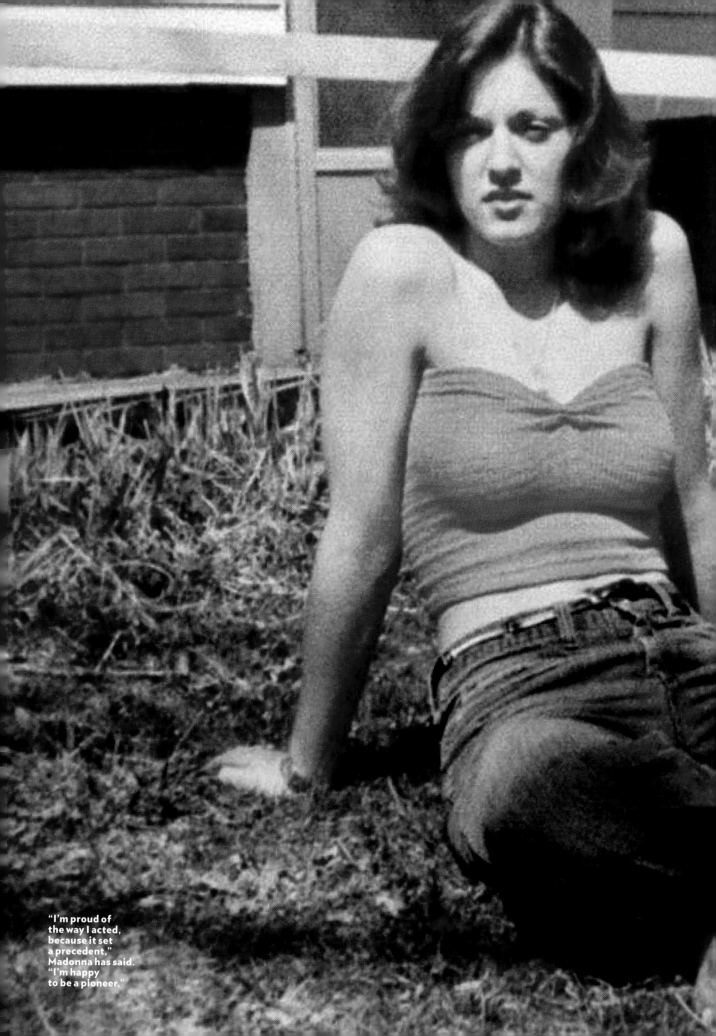

"I'm proud of the way I acted, because it set a precedent," Madonna has said. "I'm happy to be a pioneer."

MADONNA

She earned
straight A's and
a scholarship
but dropped
out of college
in pursuit
of her ultimate
dream: "to
rule the world"

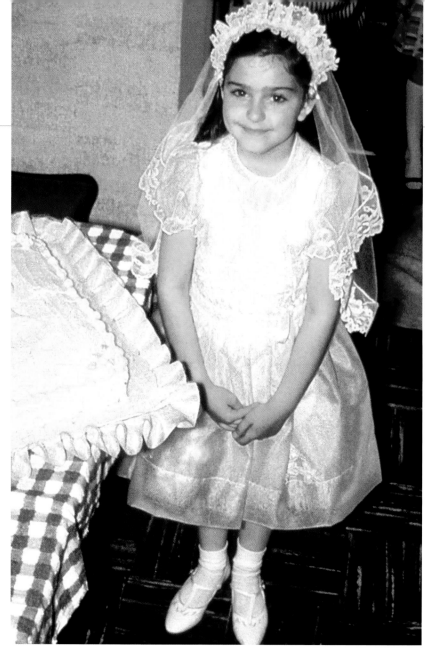

"I always said I wanted to be famous," said Madonna (at her first Holy Communion in '67 and, center, onstage in '85). "I never said I wanted to be rich."

A SWEET LITTLE GIRL FROM MICHIGAN

She has managed to stay on top of Hollywood power lists for more than 25 years. But back in the day, Madonna Louise Veronica Ciccone struggled just to get noticed.

One of six children of Tony, an auto engineer, and Madonna, a homemaker, "Little Nonni" was raised in a strict Catholic household in the Detroit suburb of Pontiac. Things got tough for the family when she lost her mother to breast cancer at age 5. After three years her father got remarried to their housekeeper, which further devastated the youngster. "From that time on I felt like Cinderella with a wicked stepmother; I couldn't wait to escape," said Madonna. She later told CNN, "I didn't accept my stepmother when I was growing up. In retrospect I think I was really hard on her." Meanwhile she began to develop a rebellious streak. "We had to wear uniforms to school, so I would put bright panty bloomers underneath," she said. "I would hang upside-down on the monkey bars at recess."

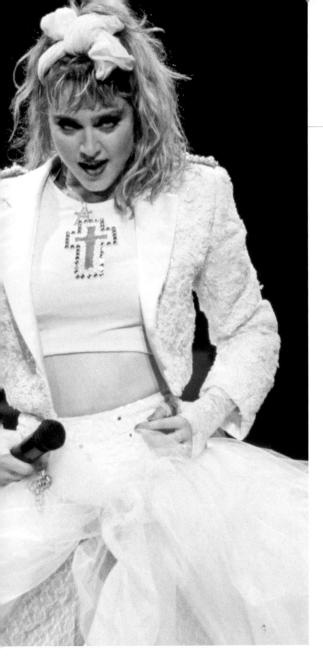

"At one point I only cared about clothes and boys and french fries," Madonna (as a teenage moll) later said. "I've grown."

Once she got to Adams High School, Madonna's desire to stand out gave her a Bad Girl reputation. "I went through this whole period of time when the girls thought I was really loose and all the guys called me a nympho," she told TIME. "If I liked a boy, I'd confront him. I've always been that way."

Reinventing herself from perky Catholic schoolgirl to punk ballerina, she landed a dance scholarship to the University of Michigan in 1976. And why not? At one point, she says, she earned all A's. After three semesters she dropped out to pursue her dreams in New York City, where she took a work-study position with the Alvin Ailey dance company. Life was a struggle. "I knew I was a decent dancer," she said. "I moved from one dive to the next, and I lived on popcorn. I was poor."

Frustrated, she decided to try music. By 1981 Madonna had already been in two bands (the Breakfast Club and Emmy) and was a veteran of the Lower East Side scene. "She acted every bit the star even then,"

Village Voice writer Michael Musto told biographer Christopher Andersen. "I thought, 'This girl is going nowhere fast.'" Demanding and ambitious, Madonna prided herself on being "resourceful," adding, "I have always been able to get my way with charm, whether it was convincing my father to let me stay out late or getting out of paying a cab fare in New York." The approach made sense to Madonna. "I am tough, ambitious and know exactly what I want," she said. "If that makes me a bitch, okay."

Her notoriety on the New York City club circuit translated into mainstream success in 1983, when she released her single "Holiday." The following year "Like a Virgin" was a smash hit and her first chance to engage in what, nearly three decades later, seems like a tradition: stirring up controversy.

In 1984 she appeared on *American Bandstand*. When Dick Clark asked about her future, including what dreams she had left, her reply—"To rule the world"— surprised almost no one.

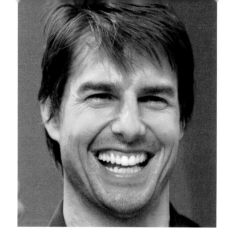

TOM

Today's star used high school sports and theater to overcome his loneliness— and never jumped on the furniture

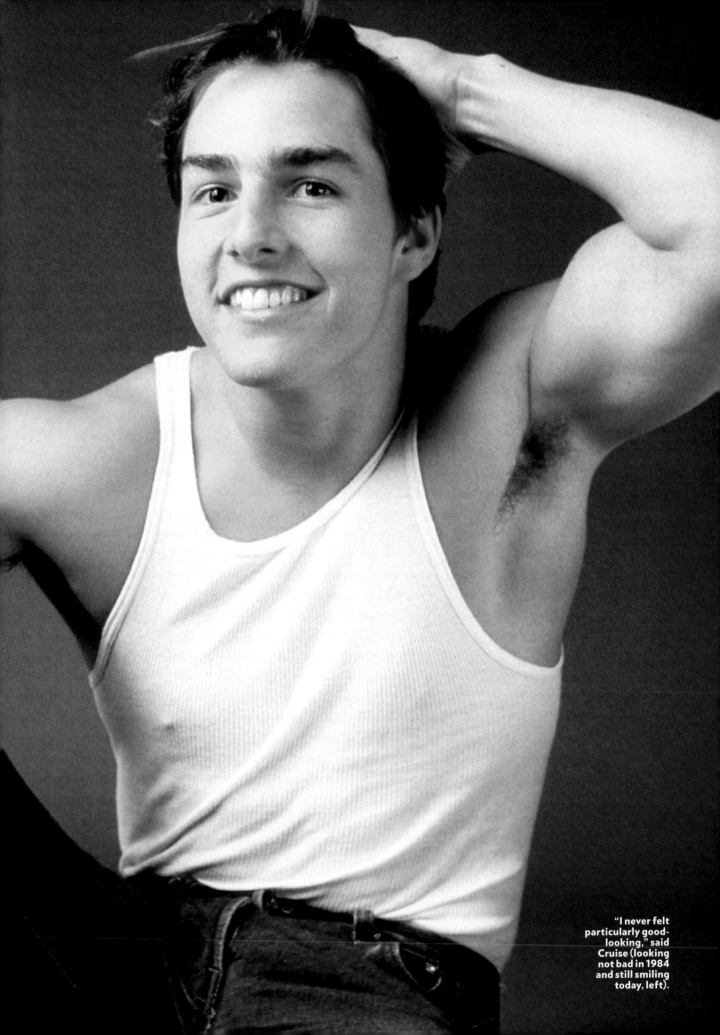

"I never felt particularly good-looking," said Cruise (looking not bad in 1984 and still smiling today, left).

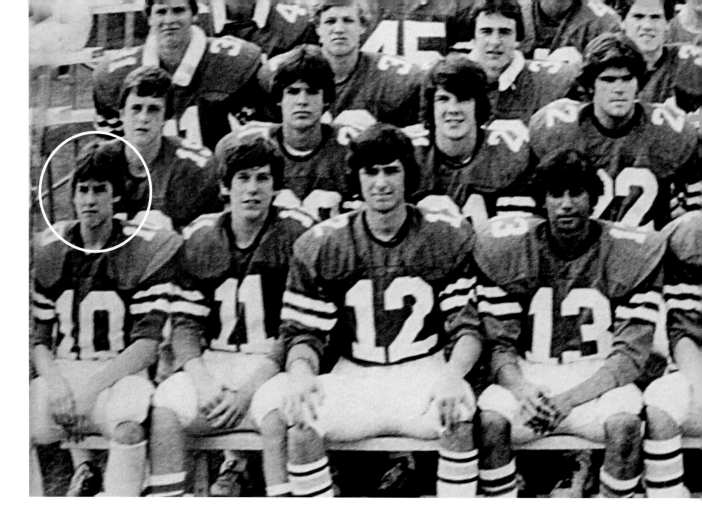

TOUGH CHILDHOOD
HUGE
AMBITION

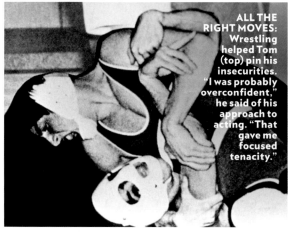

ALL THE RIGHT MOVES: Wrestling helped Tom (top) pin his insecurities. "I was probably overconfident," he said of his approach to acting. "That gave me focused tenacity."

As written, the scene didn't exactly jump off the page.

It was just "one line that said, 'Joel dances in underwear through the house,'" recalled Tom Cruise, whose improvisations in 1983's *Risky Business* gave the film its most memorable moment, pushed his fledgling career into overdrive and ended at least one boxers-or-briefs debate once and for all. "I had tried it a couple of ways where it didn't work," Cruise said of the famous tighty-whities scene. "Finally I put on socks, waxed the floor and put dirt around so I could slide right out to the center of the frame."

Smooth sailing was a new sensation for Cruise, whose unlikely rise owed less to good luck, looks and perfect teeth and loads more to tooth-and-nail

determination. An overachiever who would break away from the Brat Pack and leave some of his more marquee-ready contemporaries agog in his wake, Thomas Cruise Mapother IV seemed, despite the Roman numerals, destined for nowhere. "I was always the new kid with the wrong shoes, the wrong accent," he said about his rootless, tormented childhood. Born in Syracuse, N.Y., to a onetime amateur actress and an intermittently employed electrical engineer, Cruise has few good memories of life with father. "He was a bully and a coward," he has said of his late father, Thomas Mapother III, who struggled to keep a job and stay sober and in one place. "He was the kind of person who, if something goes wrong, kicks you."

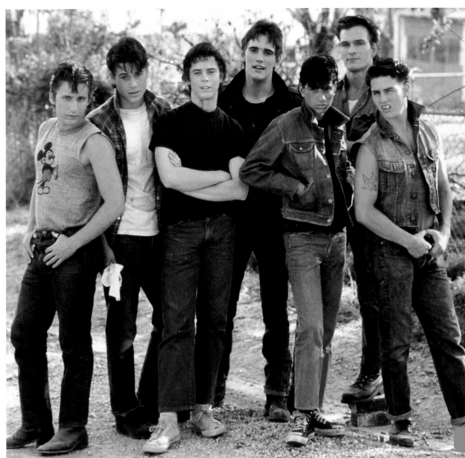

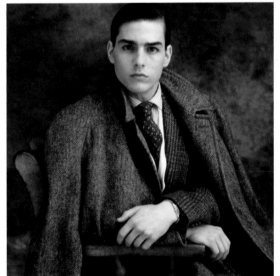

Tom's mother, Mary Lee, and three sisters weren't immune. When Cruise was 11, the couple divorced. "My mother finally had the courage to stand up to my dad and say, 'No more! I'm not taking it.'" Mary Lee and the kids moved to Louisville, where she worked three jobs to support the family. "She made it possible for us to survive," Tom said. "My mom could have sat there every morning and cried. She didn't. My mom was very proud!"

Plagued by dyslexia and bullied by bigger kids at school, Cruise struggled in the classroom and fought back on the playground. "So many times the big bully comes up, pushes me," he recalled. "Your heart's pounding, you sweat, you feel like you're going to vomit. But I know if I don't hit that guy hard, he's going to pick on me all year."

Moving to Glen Ridge, N.J., after his mother remarried, Cruise sought salvation in sports but found it onstage after he was injured wrestling. "I knew what I wanted to be," he said of starring in a school production of *Guys and Dolls.* "An actor."

Skipping graduation ceremonies, he set out for New York City, where he sat in on drama classes and worked as a building superintendent to pay the rent. After landing a small role in *Endless Love,* starring Brooke Shields, Cruise auditioned for a part in the military-school drama *Taps.* Home with his family in Glen Ridge when he learned he had won that breakthrough role, "I jumped up and smashed my head on the door frame, I was so excited," he said. "I almost knocked myself out. I remember dancing around the house with my family, we were all so excited." And why not? For Cruise success was an impossible mission, accomplished.

Famously famous as the Can't (Act, Sing, Dance) Girl, Kardashian used her material-world wiles to make a mint

KIM KARDASHIAN

Her beginnings were not exactly humble, but her ambitions were lofty. For Kardashian that meant professional closet organizer today, TV reality star tomorrow. The daughter (as if you didn't know) of mother and "momager" Kris Jenner and the late Robert Kardashian, the entrepreneur and O.J. lawyer who was by far the most important man in her life who was not a professional athlete, the *Keeping Up with the Kardashians* star, now 31, grew up in Beverly Hills, received a new Mercedes for her sweet-16 birthday and dreamed of auditioning for MTV's *Real World*. Paris Hilton and Nicole Richie were her childhood chums. While then-more-notorious friends messed around with makeup and shopped till they copped, drug-free Kim mastered the lip-gloss-and-eye-shadow arts by attending beauty school at age 14 and found ways to make as well as spend gobs of money. "I knew the Manolo Blahnik Timberland-looking boots were popular and no one could get them," she told *W* magazine. "I asked my dad if I could use his credit card and buy seven or eight pairs. I told him my business plan, and he made me sign a contract that I would pay him back within two weeks, plus interest. I sold each pair of boots on eBay for three times what I paid." And so it all began.

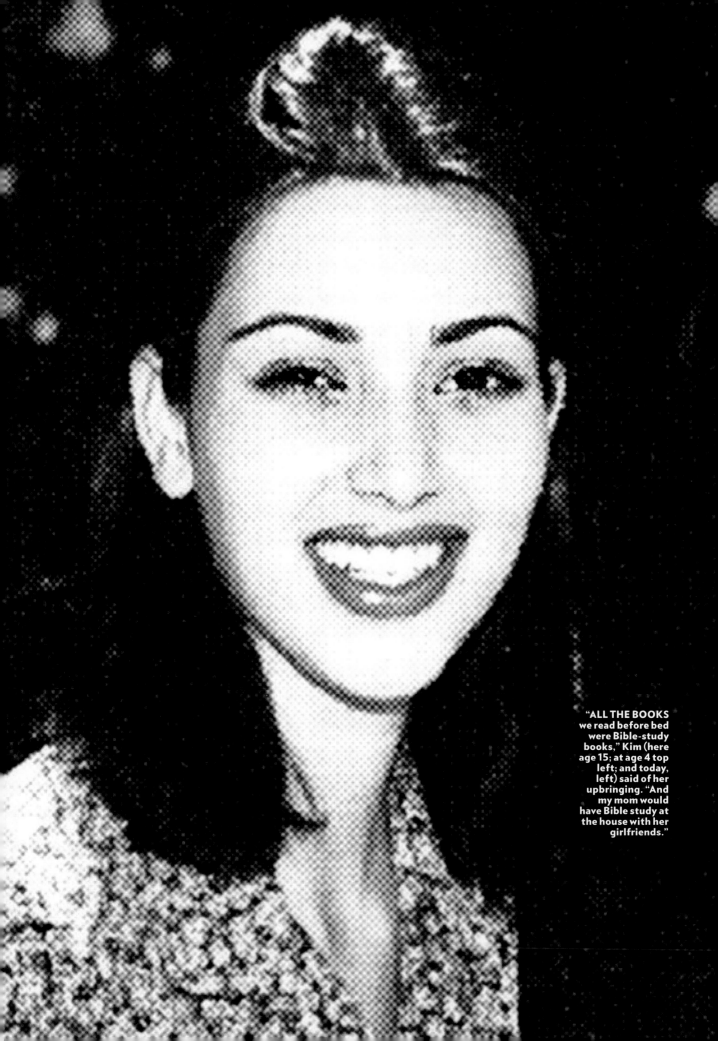

"ALL THE BOOKS we read before bed were Bible-study books," Kim (here age 15; at age 4 top left; and today, left) said of her upbringing. "And my mom would have Bible study at the house with her girlfriends."

LIGHTS! CAMERA! ACTION!

Long before they hit a soundstage, these future stars of the big and little screens were ready for their close-ups

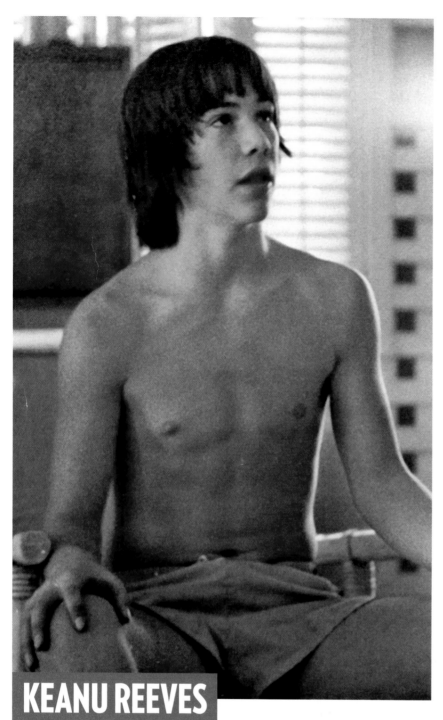

KEANU REEVES

Born in Beirut and raised in Toronto, Keanu tried 12th grade twice before dropping out and driving to Hollywood. "I even flunked gym," he told *Rolling Stone*. Critics gave him an A for his breakthrough role in 1987's edgy *River's Edge*

DANGEROUS LIAISONS SENSITIVITY TRAINING: When Reeves had trouble crying on demand, he recalled, the film's director said, "Can't you think of your mother being dead or something?"

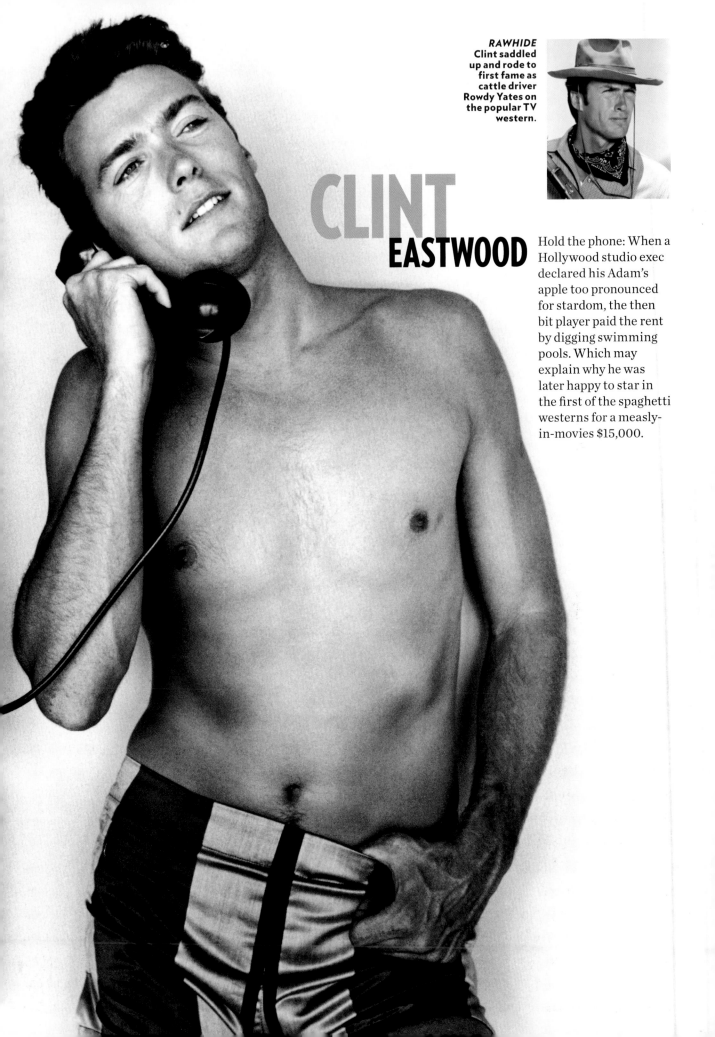

CLINT
EASTWOOD

Hold the phone: When a Hollywood studio exec declared his Adam's apple too pronounced for stardom, the then bit player paid the rent by digging swimming pools. Which may explain why he was later happy to star in the first of the spaghetti westerns for a measly-in-movies $15,000.

COLIN FARRELL

With actors plentiful as shamrock in his native Ireland, where he later started hearts a-throbbing in a BBC drama called *Ballykissangel*, Farrell worked with a troupe of line dancers in 1997. "We had to wear a Stetson, cowboy boots and choker—it made me look like a Village People version of a cowboy," he recalled. "I earned loads of money, but one day I looked at myself in the mirror and just . . . packed it in."

TIGERLAND
"He's got incredible charisma," director Joel Schumacher said of the unknown Farrell in his 2000 Vietnam film.

Bieber, who has sold 12 million albums, got his start on YouTube and was signed by Usher, who won a bidding war with Justin Timberlake. "I saw he wanted it," said Usher. "It was the same fire I had."

Four years later, his life was like "Beatlemania," his road manager said. "Mass hysteria. Loud screaming, crying, passing out. It's amazing." But in 2006, Justin Bieber, a seventh grader at Stratford Northwestern School in Stratford, Ont., had his eye on the ball; a year later he would help his team win a championship.

Justin Bieber

S. Y. S.

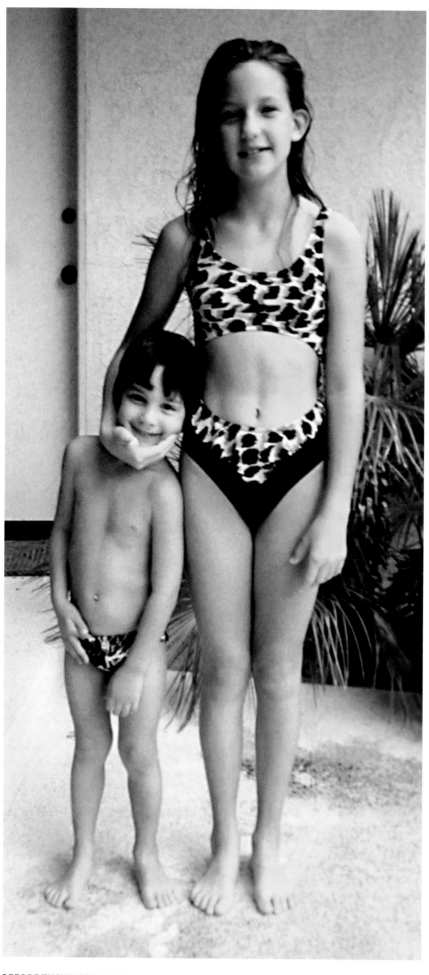

KATE
HUDSON

She has her mom's dimpled grin, but Kate, daughter of Hollywood icon Goldie Hawn, said she didn't inherit the *Laugh-In* gene. "I'm not naturally funny like my mom," said Hudson (with her brother Zachary). "People don't laugh with me, they laugh at me."

ALMOST FAMOUS
"I have zero problems when people say, 'You look like your mother,'" Kate told reporters. "I go 'Well, great! Thanks!'"

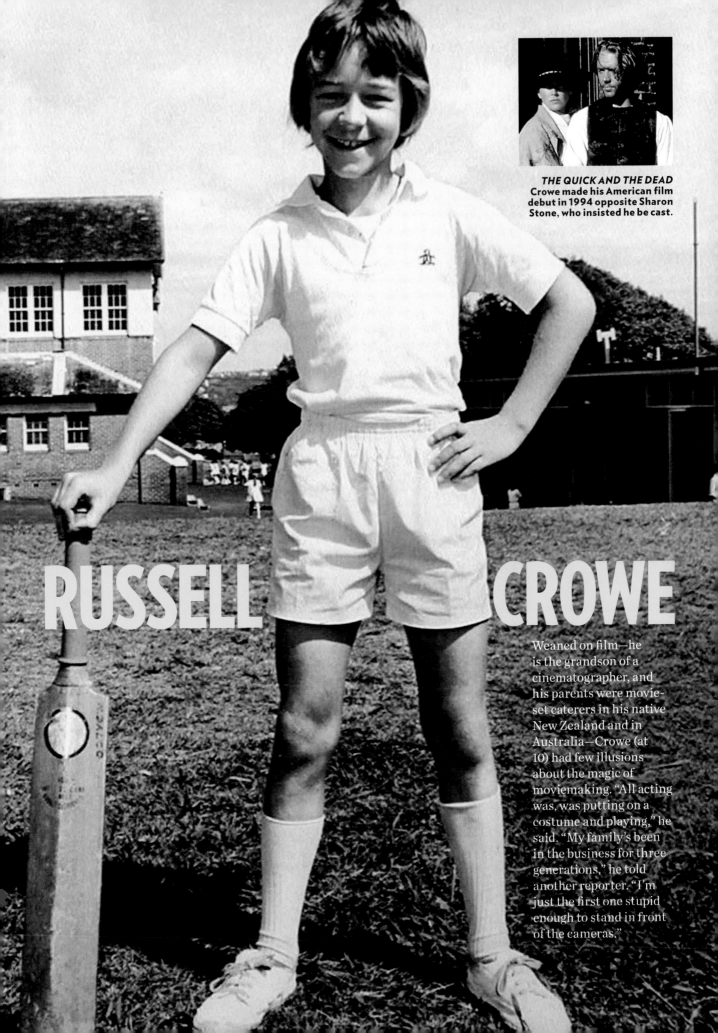

RUSSELL CROWE

Weaned on film—he is the grandson of a cinematographer, and his parents were movie-set caterers in his native New Zealand and in Australia—Crowe (at 10) had few illusions about the magic of moviemaking. "All acting was, was putting on a costume and playing," he said. "My family's been in the business for three generations," he told another reporter. "I'm just the first one stupid enough to stand in front of the cameras."

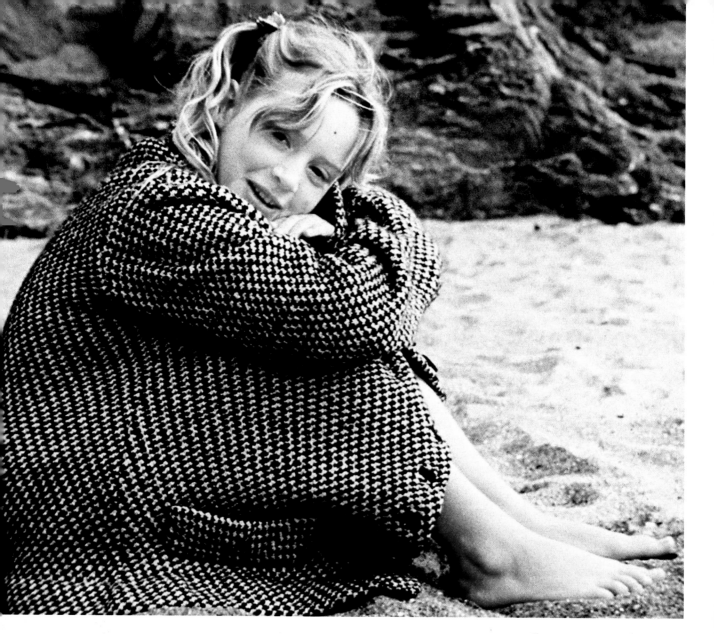

KATE WINSLET

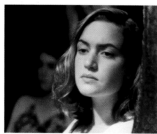

HEAVENLY CREATURES
"I cried when they cast me," the future *Titanic* star told Denver's *Rocky Mountain News* of auditioning for the 1994 Peter Jackson psycho thriller. "I was so happy!"

Choosing short-order counter work over waitressing while a 17-year-old actress-in-waiting, Kate toiled at a deli in London between auditions and appearances on the U.K. sitcom *Get Back.* "I'm perfectly happy making fancy sandwiches or serving coffee," the British-born Winslet told London's *Daily Mail.* "In fact, I was making pastrami and dill sandwiches when I received the call telling me I had the role in *Heavenly Creatures.*"

LAWRENCE FISHBURNE

Already a stage and soap vet (*One Life to Live,* below, in 1973), he was 14 when cast in *Apocalypse Now.* The 18-month shoot meant missing "the basketball team, swim team, track team . . . and dates," Fishburne later said.

PEE-WEE'S PLAYHOUSE
While playing his friend Paul Reubens's sidekick Cowboy Curtis, Fishburne met his future *Boyz n the Hood* director John Singleton, then 18 and a guard on the set.

HUGH GRANT

An Oxford grad performing with a comedy troupe and writing sketches for British TV in 1982, Grant initially resisted calls from agents who suggested he become a full-time actor. "I said, 'No, thank you, not at all,'" he told the *Canadian Press.* "But then I suddenly thought it might be quite a cool thing to say at dinner parties when girls ask you what you do. So I rang them back."

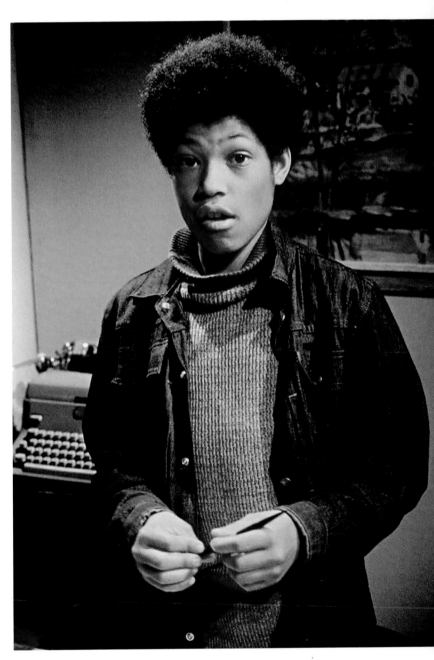

MAURICE
The 1987 James Ivory film was the first to type Grant as, he said, "upper-class young man No. 16."

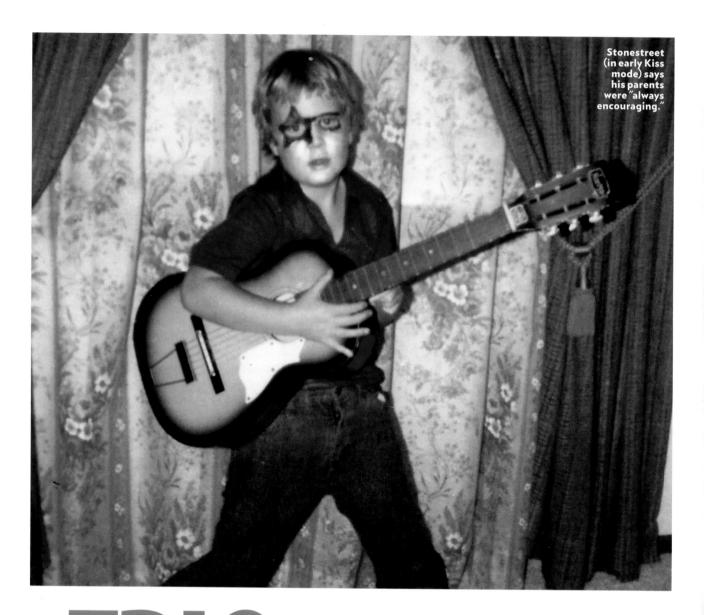

Stonestreet (in early Kiss mode) says his parents were "always encouraging."

ERIC STONESTREET

Stonestreet based his *Family* character, Cameron, on his mom, Jamey.

"I was the kid who wanted to play football *and* be a clown," says *Modern Family* star Stonestreet, who attended Piper High School in Kansas City, Kans. So he applied to Ringling Bros. and Barnum & Bailey Clown College—and was turned down. Stonestreet, however, was the type of clown who took a punch and popped back up: He brought his clown act to *Family,* and it helped him win an Emmy.

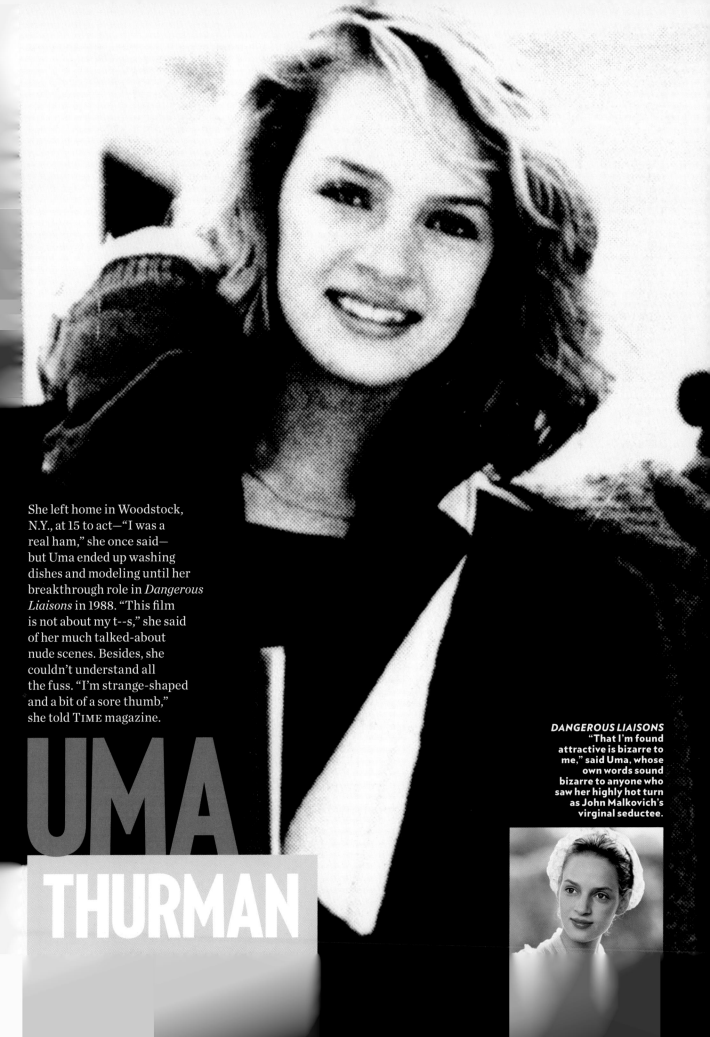

She left home in Woodstock, N.Y., at 15 to act—"I was a real ham," she once said— but Uma ended up washing dishes and modeling until her breakthrough role in *Dangerous Liaisons* in 1988. "This film is not about my t--s," she said of her much talked-about nude scenes. Besides, she couldn't understand all the fuss. "I'm strange-shaped and a bit of a sore thumb," she told TIME magazine.

UMA
THURMAN

DANGEROUS LIAISONS "That I'm found attractive is bizarre to me," said Uma, whose own words sound bizarre to anyone who saw her highly hot turn as John Malkovich's virginal seductee.

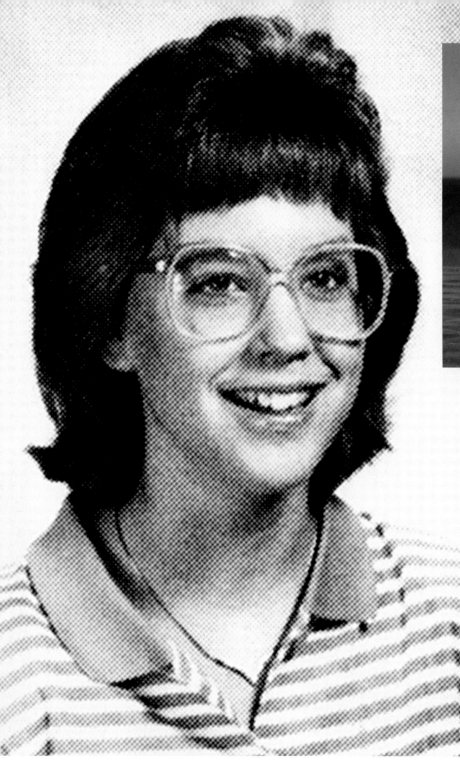

"Some days I think, 'I can't do this,'" Gosselin says of excercising. "Then I tell myself, 'You can and you will.'"

Once, she was just little Katie Kreider, a ninth grader at Mount Calvary Christian Academy in Elizabethtown, Pa. And then ... a *lot* happened: eight kids; a reality TV show hit; a very messy, very public divorce; and, after the dust settled, a dramatic makeover (see above). Gosselin says she got fit by dieting and running: "Every day, no matter ... how tired I feel, I get up, and I run again."

KATE
GOSSELIN

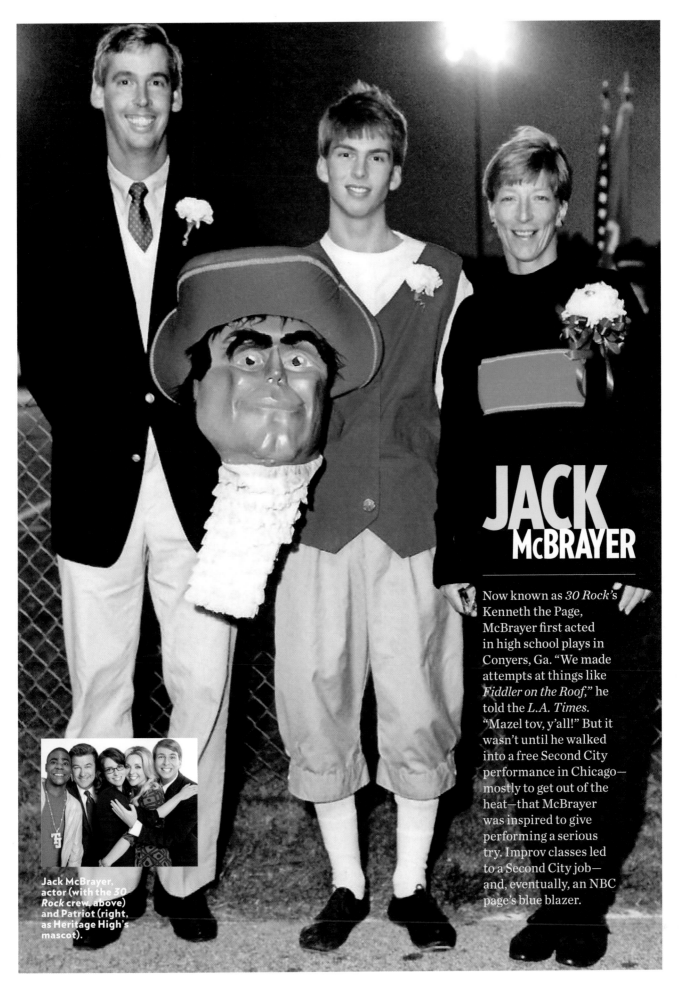

JACK McBRAYER

Now known as *30 Rock's* Kenneth the Page, McBrayer first acted in high school plays in Conyers, Ga. "We made attempts at things like *Fiddler on the Roof*," he told the *L.A. Times*. "Mazel tov, y'all!" But it wasn't until he walked into a free Second City performance in Chicago—mostly to get out of the heat—that McBrayer was inspired to give performing a serious try. Improv classes led to a Second City job—and, eventually, an NBC page's blue blazer.

Jack McBrayer, actor (with the *30 Rock* crew, above) and Patriot (right, as Heritage High's mascot).

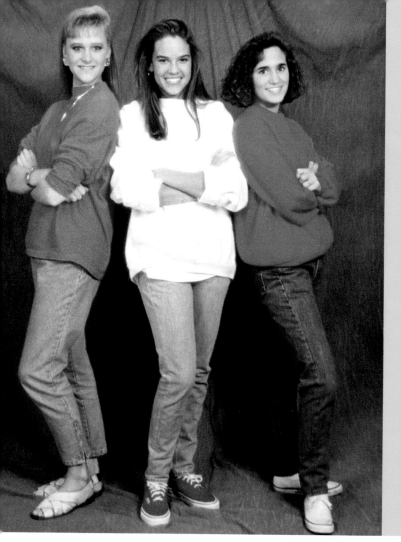

HILARY SWANK

She grew up to be a million-dollar baby—and win two Academy Awards for Best Actress—but here Hilary Swank is just one of the girls, with pals Heather Hulbert (right) and Kristin Kimball (left) in their hometown of Bellingham, Wash.

THE NEXT KARATE KID In this 1994 movie, Swank's second film, the actress portrayed an angry teenager who takes up karate.

GWYNETH PALTROW

FLESH AND BONE Paltrow was 21 when she earned kudos as a thieving, whiskey-swilling, breast-baring bad girl.

Every actress confronts the nudity question. For Gwyneth it was sooner than most. "Gwynnie knew my lines better than I did," her mom, Blythe Danner, recalled of a summer stock production of *The Seagull*, in which Gwyneth, then 1, recited Chekhov during a rehearsal. "She was naked, all blonde curls flowing," Danner said. When mother and daughter costarred in another *Seagull* 20 years later, Gwynnie kept her clothes on.

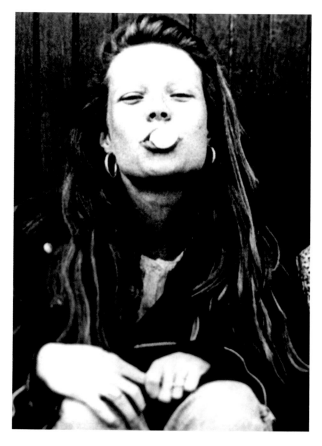

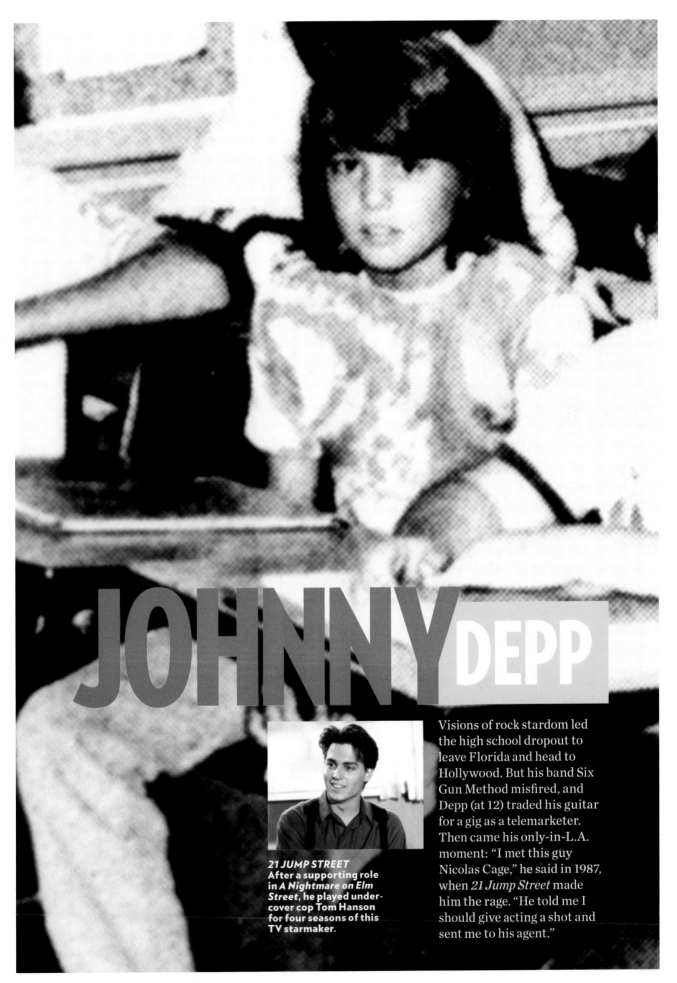

JOHNNY DEPP

21 JUMP STREET
After a supporting role in *A Nightmare on Elm Street*, he played undercover cop Tom Hanson for four seasons of this TV starmaker.

Visions of rock stardom led the high school dropout to leave Florida and head to Hollywood. But his band Six Gun Method misfired, and Depp (at 12) traded his guitar for a gig as a telemarketer. Then came his only-in-L.A. moment: "I met this guy Nicolas Cage," he said in 1987, when *21 Jump Street* made him the rage. "He told me I should give acting a shot and sent me to his agent."

STRIKE A POSE

Candid camera shots can be cute and entertaining, but there's nothing like a professional photography session to bring out the best in a soon-to-be celebrity

ROBERT
PATTINSON

Before *Twilight*, there was the dawn: a teenage Pattinson sitting around in his (actually, probably someone else's) underwear, a pale male model. Then, at 17, he got his first rocket-boost of fame, playing dashing wizard Cedric Diggory in *Harry Potter and the Goblet of Fire*. "The day before, I was just sitting in Leicester Square, happily being ignored by everyone," he recalled of the premiere. "Then suddenly strangers are screaming your name. Amazing!"

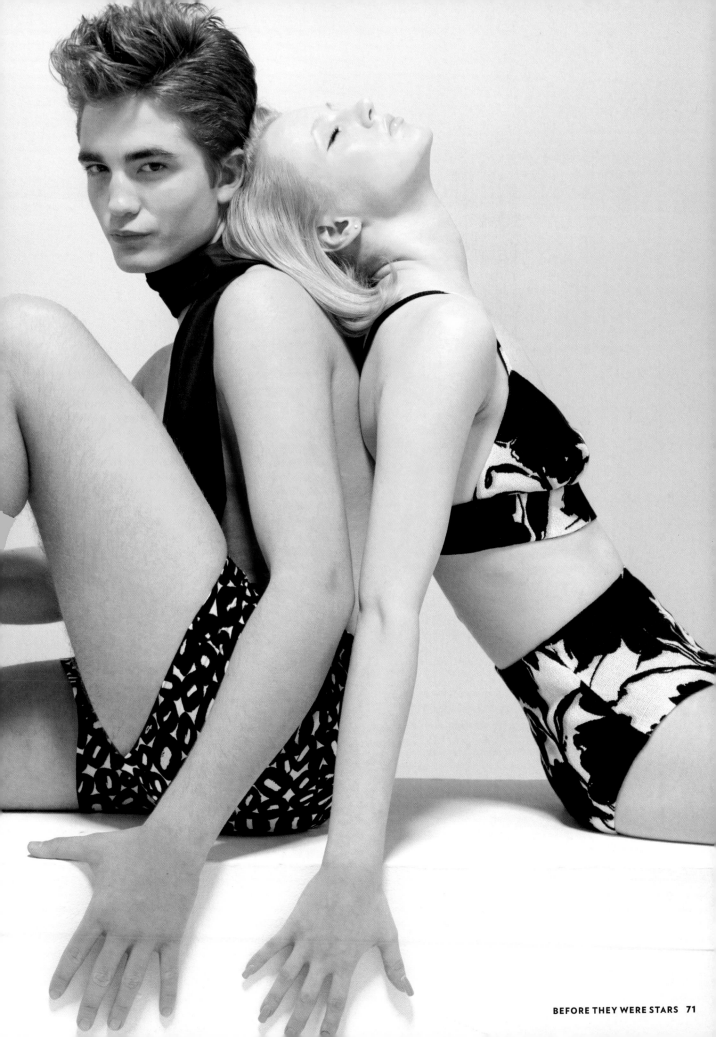

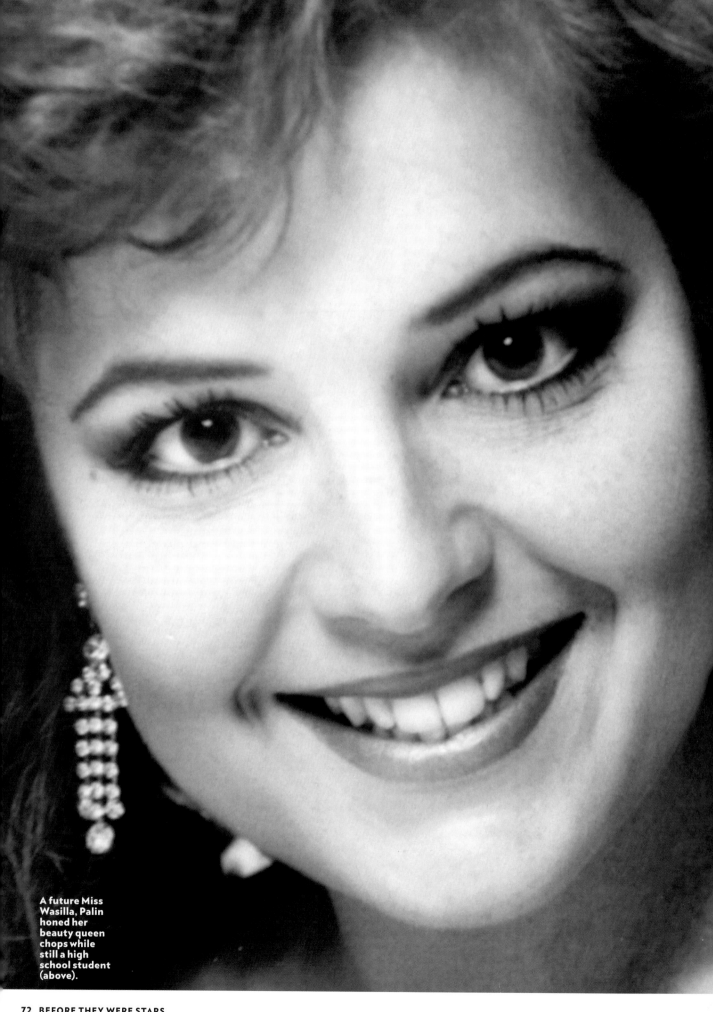

A future Miss Wasilla, Palin honed her beauty queen chops while still a high school student (above).

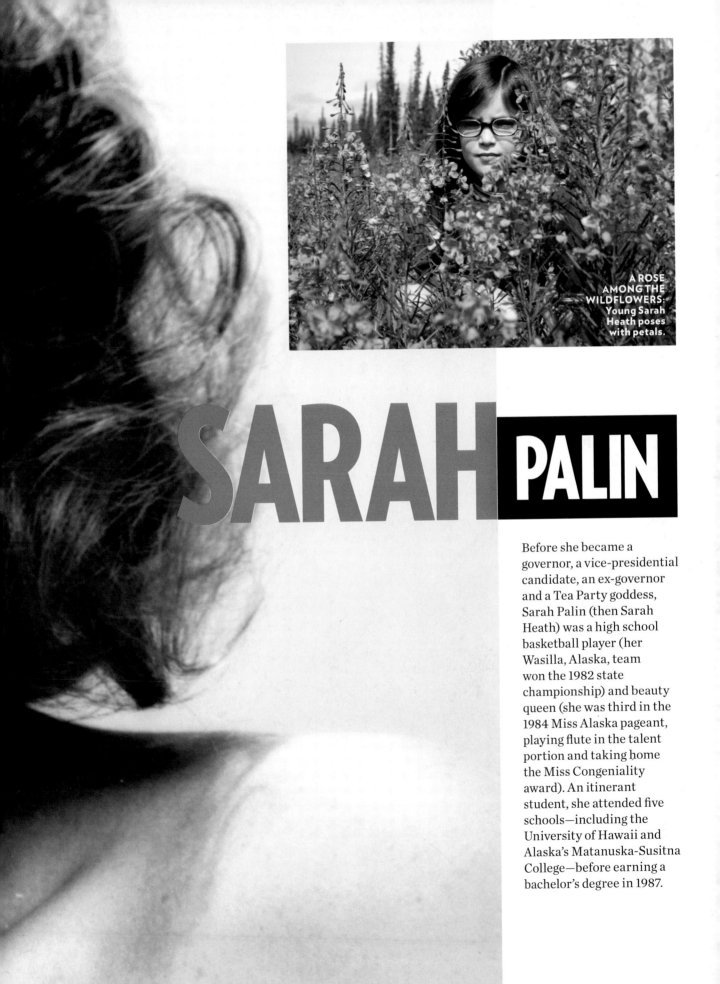

A ROSE AMONG THE WILDFLOWERS: Young Sarah Heath poses with petals.

SARAH PALIN

Before she became a governor, a vice-presidential candidate, an ex-governor and a Tea Party goddess, Sarah Palin (then Sarah Heath) was a high school basketball player (her Wasilla, Alaska, team won the 1982 state championship) and beauty queen (she was third in the 1984 Miss Alaska pageant, playing flute in the talent portion and taking home the Miss Congeniality award). An itinerant student, she attended five schools—including the University of Hawaii and Alaska's Matanuska-Susitna College—before earning a bachelor's degree in 1987.

COLIN FARRELL

Mindful, perhaps, that this outfit might invite comment from the lads in his local, young Colin left his home in the posh Dublin 'burb of Castleknock and traveled Down Under for this over-the-top photo shoot.

TANKS VERY MUCH: Farrell, 19, smoldered in Sydney in 1995.

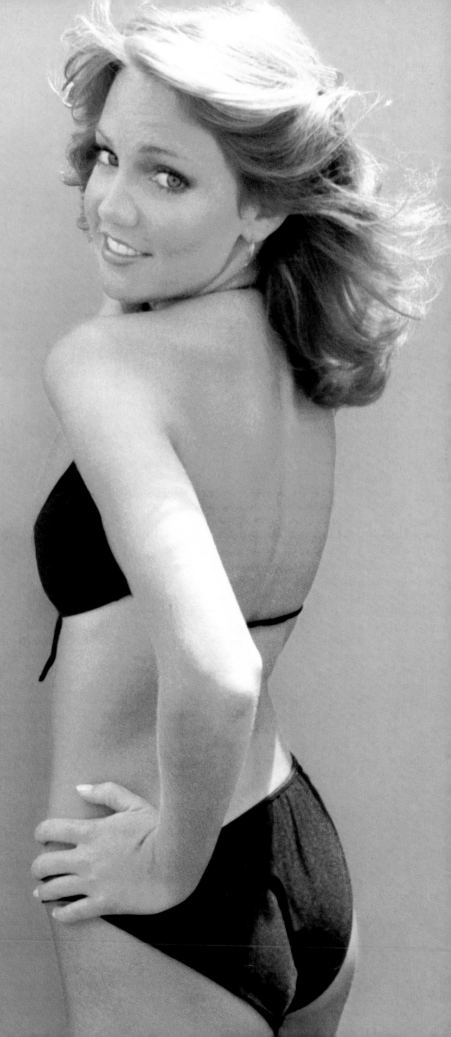

HEATHER
LOCKLEAR

Destined for *Dynasty* and a *Melrose Place* in our hearts, Heather was always at home in a swimsuit. She began her career modeling for the campus store at UCLA, where her father was an administrator. Soon came ads for Pepsi, Polaroid and the California Dairy Council.

Fourteen years after this 1978 photo, *Melrose* would play on the beauty's not-so-sunny side.

NICOLETTE SHERIDAN

How to explain the look on 17-year-old pop star Leif Garrett's face? After much study, scientists agree that his expression says, "I absolutely cannot believe this, but for some reason, my mother has allowed my 15-year-old English girlfriend Nicollette to move in with us. Yes, I am completely stunned." The two stayed together for six years, until 1985, when her career began to hit high gear. "I grew up feeling like the ugly duckling," she said. You molt, girl.

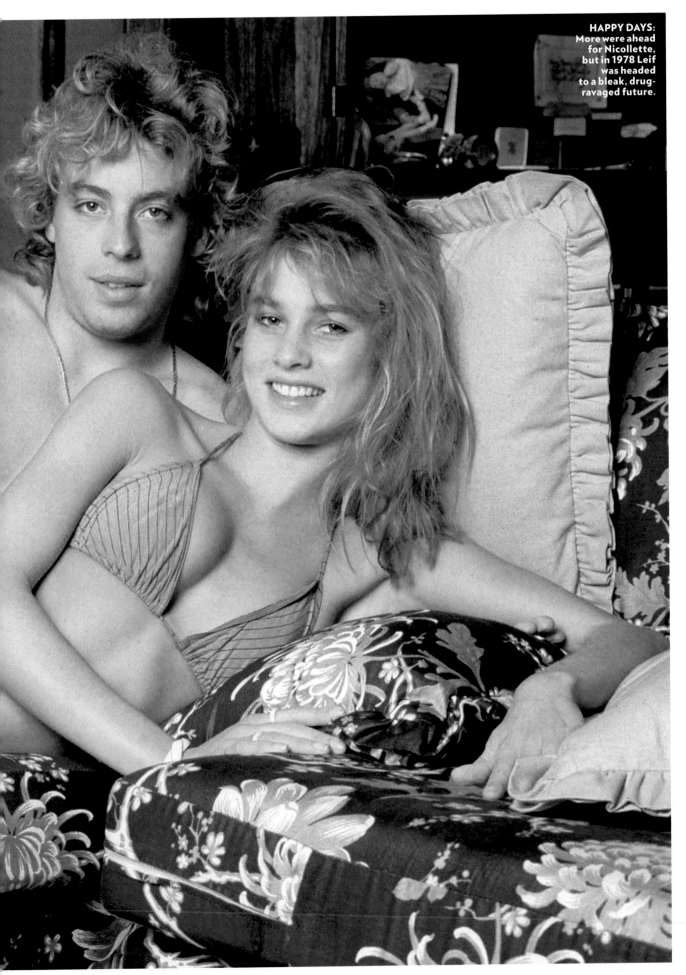

HAPPY DAYS:
More were ahead
for Nicollette,
but in 1978 Leif
was headed
to a bleak, drug-
ravaged future.

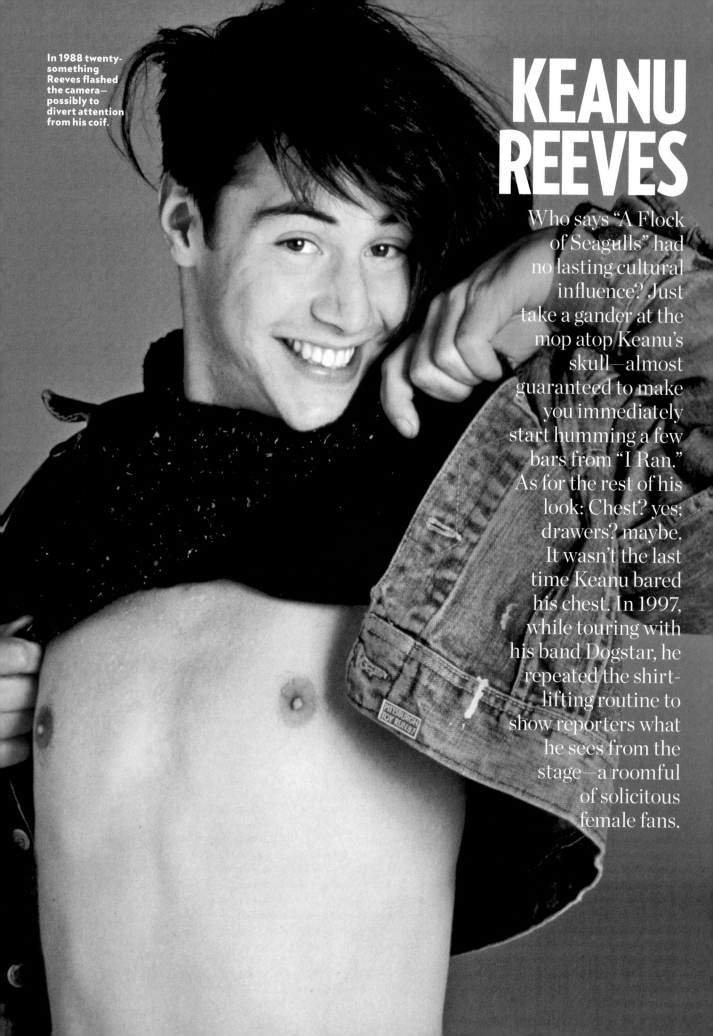

In 1988 twenty-something Reeves flashed the camera—possibly to divert attention from his coif.

KEANU REEVES

Who says "A Flock of Seagulls" had no lasting cultural influence? Just take a gander at the mop atop Keanu's skull—almost guaranteed to make you immediately start humming a few bars from "I Ran." As for the rest of his look: Chest? yes; drawers? maybe. It wasn't the last time Keanu bared his chest. In 1997, while touring with his band Dogstar, he repeated the shirt-lifting routine to show reporters what he sees from the stage—a roomful of solicitous female fans.

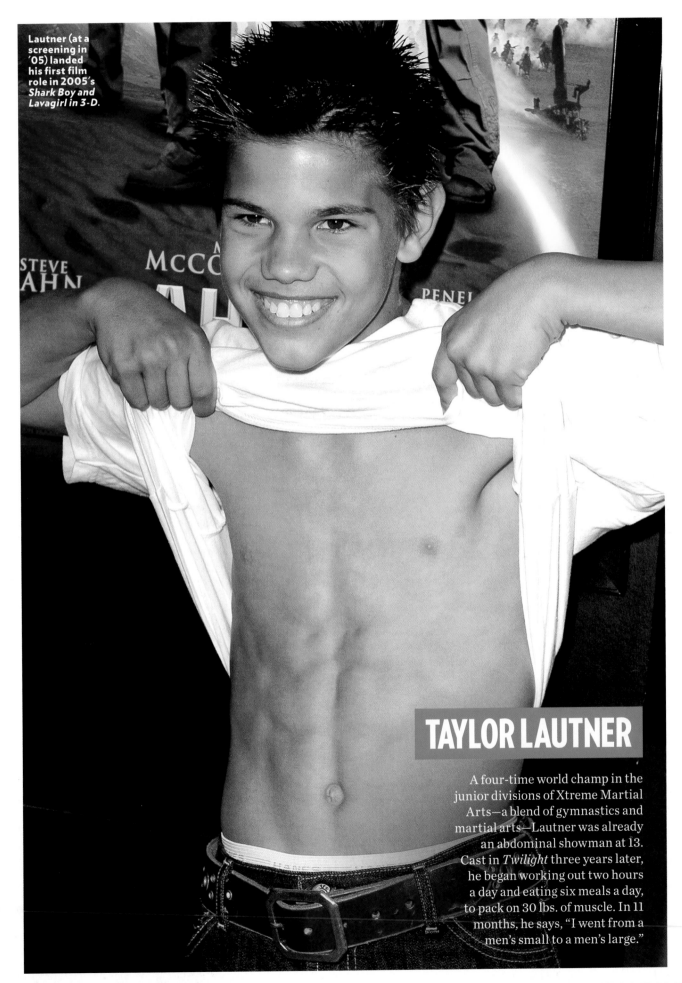

Lautner (at a screening in '05) landed his first film role in 2005's *Shark Boy and Lavagirl in 3-D*.

TAYLOR LAUTNER

A four-time world champ in the junior divisions of Xtreme Martial Arts—a blend of gymnastics and martial arts—Lautner was already an abdominal showman at 13. Cast in *Twilight* three years later, he began working out two hours a day and eating six meals a day, to pack on 30 lbs. of muscle. In 11 months, he says, "I went from a men's small to a men's large."

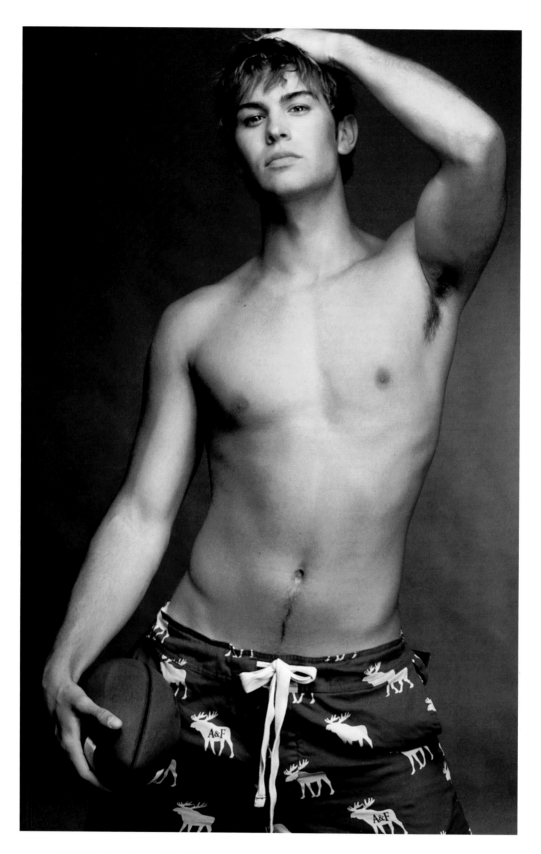

CHACE
CRAWFORD

Before he became one of *Gossip Girl*'s gossiped-about guys, Crawford worked as one of the handsome "greeters" who stand outside Abercrombie & Fitch stores. "They played the same three CDs all day long," he says. "Time would drag on. I would beg them to let me work the cash register."

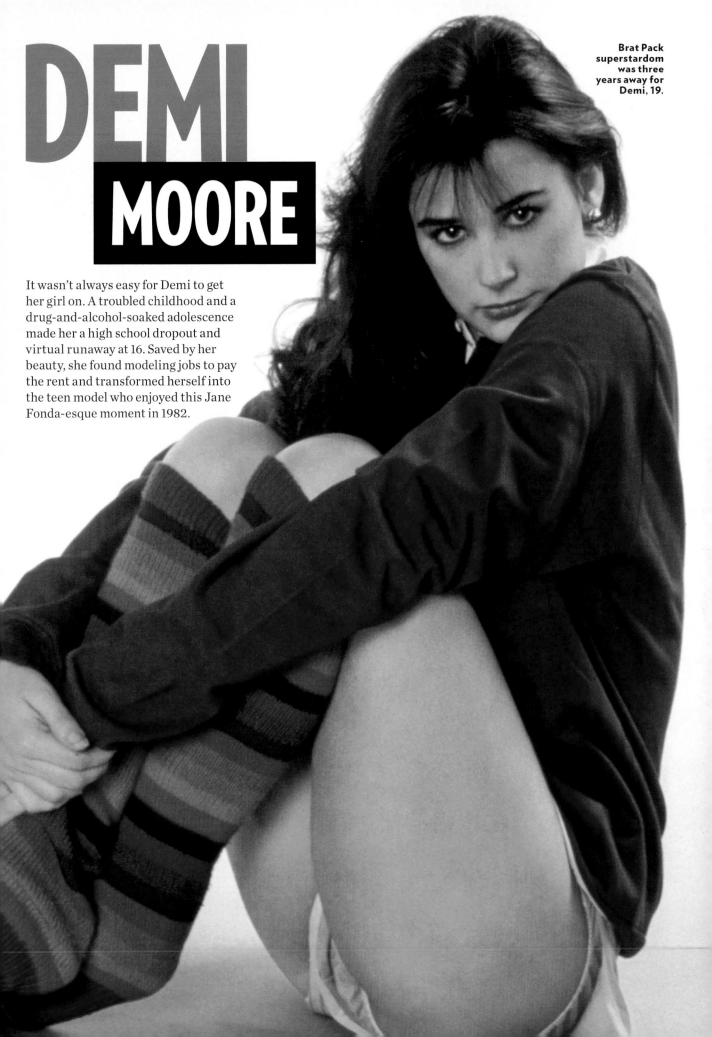

DEMI
MOORE

It wasn't always easy for Demi to get her girl on. A troubled childhood and a drug-and-alcohol-soaked adolescence made her a high school dropout and virtual runaway at 16. Saved by her beauty, she found modeling jobs to pay the rent and transformed herself into the teen model who enjoyed this Jane Fonda-esque moment in 1982.

Brat Pack superstardom was three years away for Demi, 19.

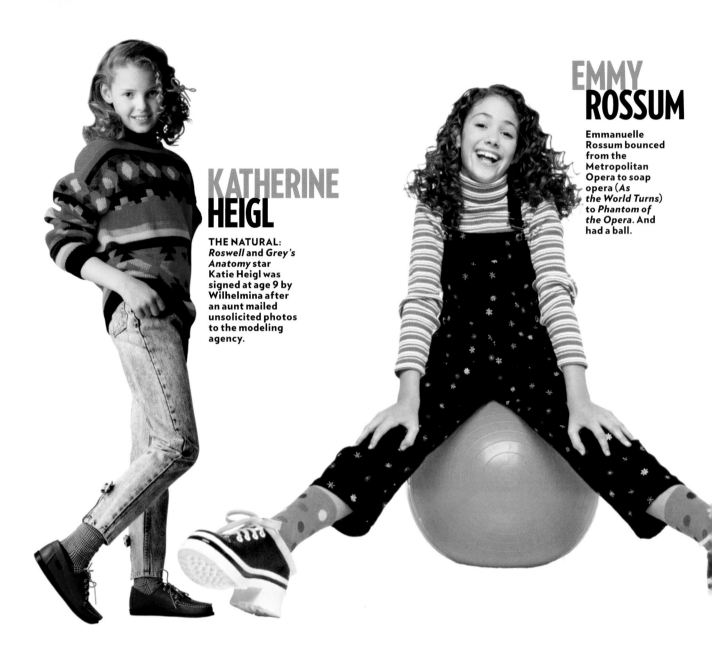

KATHERINE HEIGL

THE NATURAL: *Roswell* and *Grey's Anatomy* star Katie Heigl was signed at age 9 by Wilhelmina after an aunt mailed unsolicited photos to the modeling agency.

EMMY ROSSUM

Emmanuelle Rossum bounced from the Metropolitan Opera to soap opera (*As the World Turns*) to *Phantom of the Opera*. And had a ball.

MODEL CHILDREN

Born to be rep'd: Tykes of all stripes—and plaids—used oodles of charm, chutzpah and cute to kick off their glad rags-to-riches careers

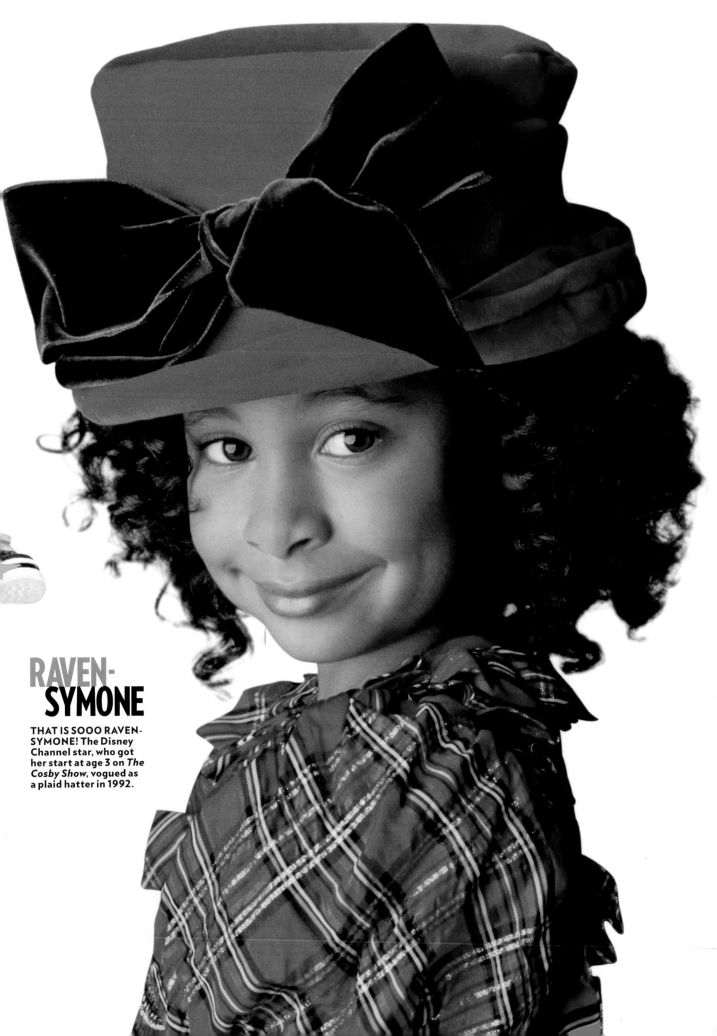

RAVEN-SYMONE

THAT IS SOOO RAVEN-SYMONE! The Disney Channel star, who got her start at age 3 on *The Cosby Show*, vogued as a plaid hatter in 1992.

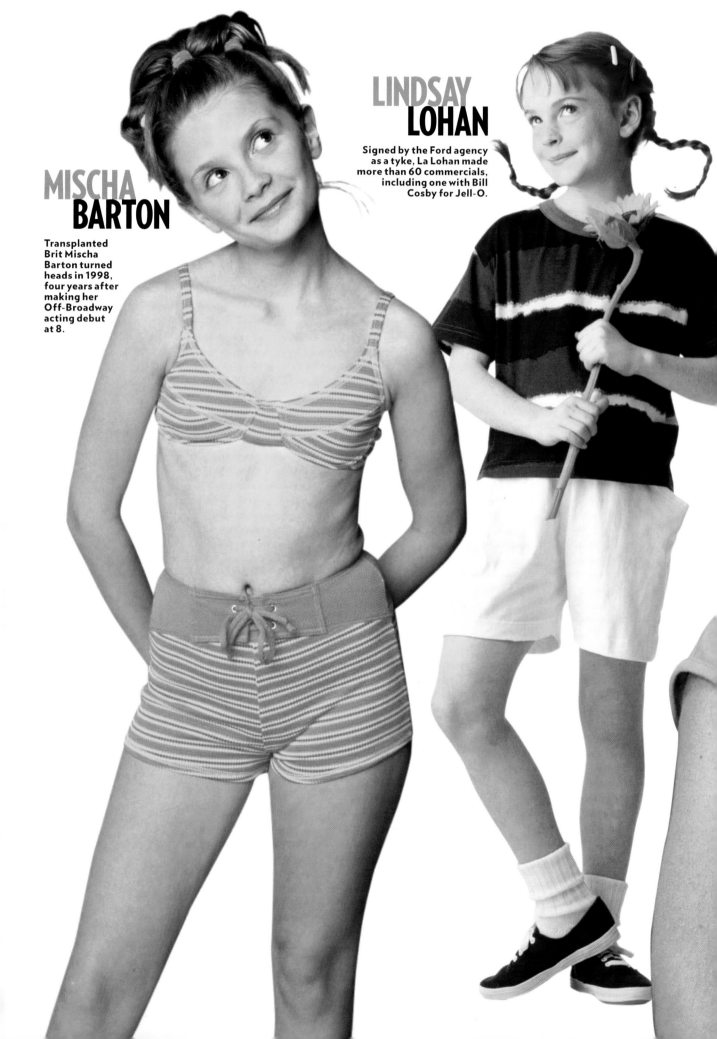

MISCHA
BARTON

Transplanted
Brit Mischa
Barton turned
heads in 1998,
four years after
making her
Off-Broadway
acting debut
at 8.

LINDSAY
LOHAN

Signed by the Ford agency
as a tyke, La Lohan made
more than 60 commercials,
including one with Bill
Cosby for Jell-O.

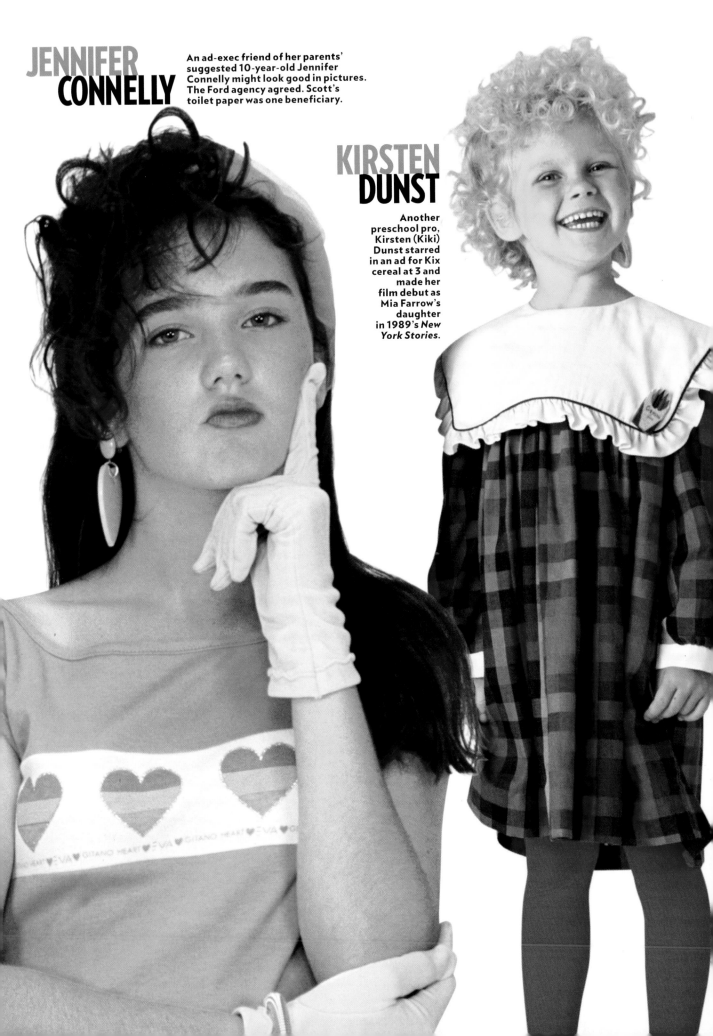

JENNIFER CONNELLY

An ad-exec friend of her parents' suggested 10-year-old Jennifer Connelly might look good in pictures. The Ford agency agreed. Scott's toilet paper was one beneficiary.

KIRSTEN DUNST

Another preschool pro, Kirsten (Kiki) Dunst starred in an ad for Kix cereal at 3 and made her film debut as Mia Farrow's daughter in 1989's *New York Stories*.

They started reptile clubs, majored in bio chem and cut class (have a note, Mariah?). Check out these A-lister stars before they hit Hollywood

CELEBRITY

HIGH

YEARBOOK

All in the Family, Aerosmith, *Rocky* and the fall of Richard Nixon

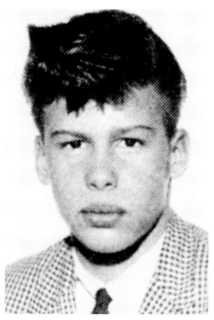

STEVEN TYLER '64

HIGH SCHOOL: Theodore Roosevelt High School, Yonkers, N.Y. **CLASSMATES KNEW HIM AS:** Steven Tallarico **HITTING MORE THAN THE BOOKS:** Wrote in *Walk This Way* that he would start his day with a shot of Dewar's scotch. **HAIR CARE HINTS?** Connected a hose to the family dryer to blow out his hair to the proper level of fluff.

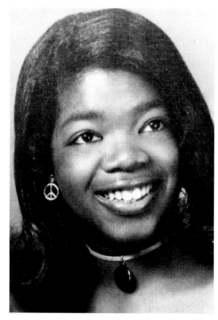

OPRAH WINFREY '71

HIGH SCHOOL: East Nashville High School, Nashville, Tenn. **GIFT OF GAB:** Oprah got practice speaking as a member of the speech team. She also won an oratory competition that netted her a scholarship to Tennessee State University. **NEVER FORGOT:** Invited her 1971 prom date, Anthony Otey, on her TV show in 1993.

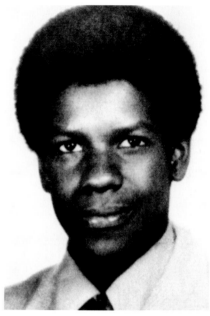

DENZEL WASHINGTON '72

HIGH SCHOOL: Oakland Academy, New Windsor, N.Y. **CLUB KID:** As a member of Boys & Girls Club of America, he was named Police Chief for a Day. **SPORTS:** Denzel was a popular student who excelled at sports, played in the band and showed an interest in the arts.

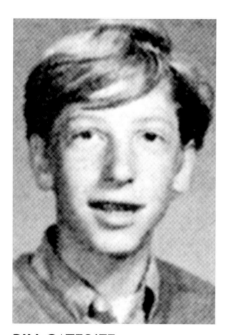

BILL GATES '73

HIGH SCHOOL: Lakeside School, Seattle **RUMMAGE SALE HEARD 'ROUND THE WORLD:** School moms raised money to buy computer time for students. **WHERE THE GIRLS ARE:** Wrote Lakeside's scheduling program; mysteriously wound up in classes with lots of females. **NUMBERS GUY:** Scored 1590 on his SATs.

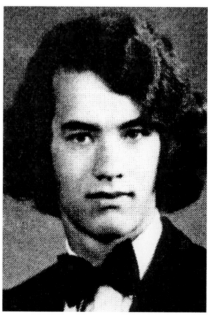

TOM HANKS '74

HIGH SCHOOL: Skyline High School, Oakland **GOOD SPORT:** Young Hanks played soccer and ran track. **PRAISE THE LORD:** While in high school, Hanks joined a fundamentalist Christian movement affiliated with the First Covenant Church in Oakland.

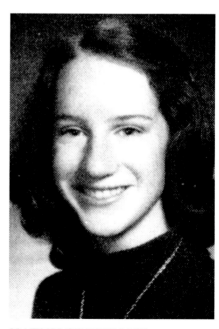

KATHY GRIFFIN '78

HIGH SCHOOL: Oak Park & River Forest High School, Oak Park, Ill. **ASSESSMENT:** "I was a giant nerd. I know that's hard to believe." **AS A CHEERLEADER, WAS REQUIRED TO MAKE BROWNIES FOR SOCCER PLAYERS—THEN DROPPED FROM SQUAD:** "That hurt. I put my heart and soul into that Duncan Hines mix."

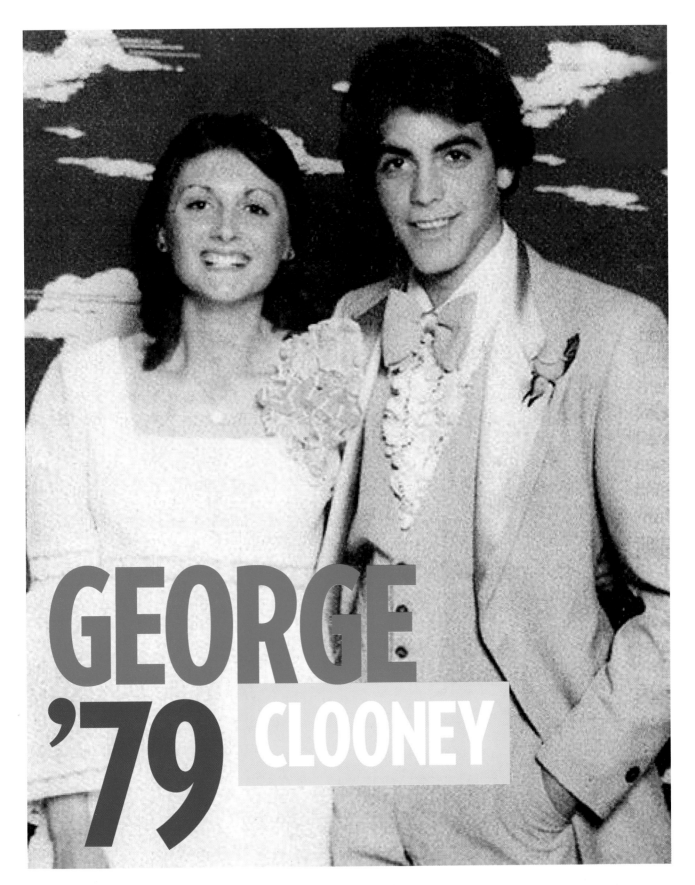

GEORGE '79 CLOONEY

HIGH SCHOOL: Augusta High School, Ky. **BIG MAN, LITTLE CAMPUS:** He served as president of the science club, played baseball and basketball and was also elected prince of the school prom. **COMPETITION WASN'T TOO TOUGH:** There were only 26 students in his class.

The Reagan years, *The Cosby Show,* Apple's Macintosh and Bon Jovi

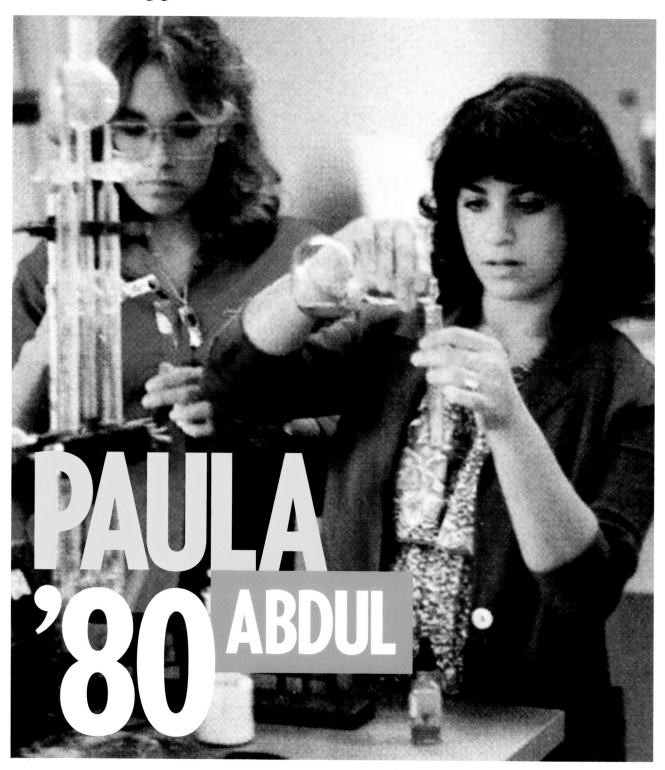

PAULA '80 ABDUL

HIGH SCHOOL: Van Nuys High School, Van Nuys, Calif. **ACTIVITY:** Elected head of the school's cheerleading squad. She was also senior class president and a member of the speech, debate and science teams. **HONOR ROLL:** Graduating with a 3.85 GPA, Abdul enrolled at Cal State-Northridge, majoring in TV and radio.

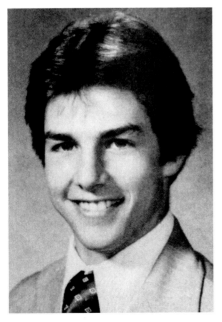

TOM CRUISE '80

HIGH SCHOOL: Glen Ridge High School, Glen Ridge, N.J. THE SPORTING KIND: He had to quit the wrestling team after a knee injury, but it may have been a blessing in disguise. Cruise switched to drama and played Nathan Detroit in the school play *Guys and Dolls*. "It was the first thing in my life for a long, long time that I felt excited about," he said.

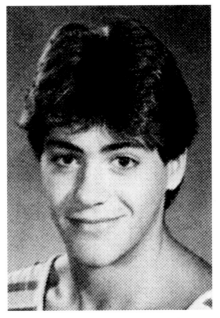

ROBERT DOWNEY JR '82

HIGH SCHOOL: Santa Monica High School, Santa Monica, Calif. THE LOOK: "I had this bad-boy-from–New York vibe going . . . but I was anything but a badass. I was listening to the Clash and Black Flag because I was told I should, but I really wanted to listen to Phil Collins." EARLY EXIT: He dropped out at 17 to try acting.

COURTENEY COX '82

HIGH SCHOOL: Mountain Brook High School, Birmingham, Ala. NICKNAME: At home she was called CeCe. GOOD SPORT: Arquette excelled at cheerleading, swimming and playing tennis.

TERI HATCHER '82

HIGH SCHOOL: Fremont High School, Sunnyvale, Calif. GIMME A "T": Hatcher was captain of Fremont's cheerleading squad. A BRUSH WITH OBSCURITY: Her graduating class voted her Most Likely to Be a Solid Gold Dancer.

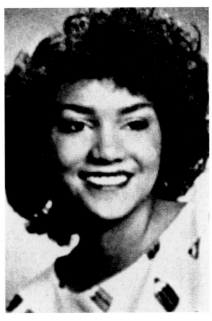

HALLE BERRY '84

HIGH SCHOOL: Bedford High School, Bedford, Ohio SCOOP: Berry was the editor of Bedford's school paper. MONSTROUS BALL: In a hotly contested derby for prom queen, Berry and friends were accused of stuffing the ballot box to put her over the top. She won the crown with a coin toss and avoided the possibility of a recount.

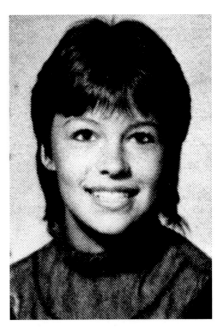

PAMELA ANDERSON '85

HIGH SCHOOL: Highland Secondary School, Comox, B.C. GOAL: "To be a California beach bum." (Anderson later patrolled the beaches on *Baywatch*.) CLOTHES: Although Anderson got her break by stretching out a Labatt's T-shirt, in school it was mostly sweatpants, sweatshirts and no makeup. "It felt so gross that I took it off," she said.

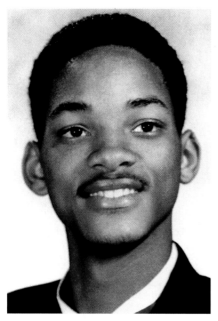

WILL SMITH '86

HIGH SCHOOL: Overbrook High School, Philadelphia **NICKNAME:** Prince Charming, given by teachers amused by Smith's smooth excuses for missing assignments. As for the ladies . . . "I desperately needed a date doctor in high school," said Smith of his lack of dating skills. "I wasn't anybody's first choice. I was skinny; my ears kind of stick out."

KENNY CHESNEY '86

HIGH SCHOOL: Gibbs High School, Corryton, Tenn. **TRIPLE THREAT:** Chesney was well on his way to keeping his signature size 29 waist by playing basketball, baseball and football. **BOOKWORM:** This jock didn't skip out on homework. He enjoyed it. Since doing a book report on Hemingway's *The Old Man and the Sea*, the singer says, he's reread the classic 25 times.

FAITH HILL '86

HIGH SCHOOL: McLaurin Attendance Center, Florence, Miss. **JANE OF ALL TRADES:** Voted Most Popular, Class Favorite and Most Beautiful; the southern beauty also ran track, shot hoops and cheered. **A STAR IS BORN:** Hill sang in the Star Baptist Church choir in Star, Miss. A true Southerner, her favorite drink is sweet tea.

JENNIFER LOPEZ '87

HIGH SCHOOL: Preston High School, New York City **LISTENING TO MOM AND DAD:** "I told my parents I'm not going to go to college, I'm not going to go to law school . . . [and] I got no support," she said. "To go off to be a movie star was just stupid because there were no Latinas who do that." Lopez did briefly attend New York City's Baruch College.

OWEN WILSON '87

HIGH SCHOOL: New Mexico Military Institute, Roswell, N.Mex. **EXPELLED:** From St. Mark's School of Texas in the 10th grade and shipped off for regimented training. Wilson recalled he "stole the geometry teacher's book, which had . . . answers [to a test] . . . and I gave it out to all my classmates so everyone got A's."

QUEEN LATIFAH '87

HIGH SCHOOL: Frank H. Morrell, Irvington, N.J., where her mother taught for nearly two decades. **SHE GOT GAME:** The former Dana Owens, whose moniker "Latifah" is Arabic for "delicate, kind," played power forward on Morrell's basketball team. **MUSICAL:** She started rapping as a teenager, then formed a rhyming group, Ladies Fresh, with two friends. The trio easily won a school talent contest.

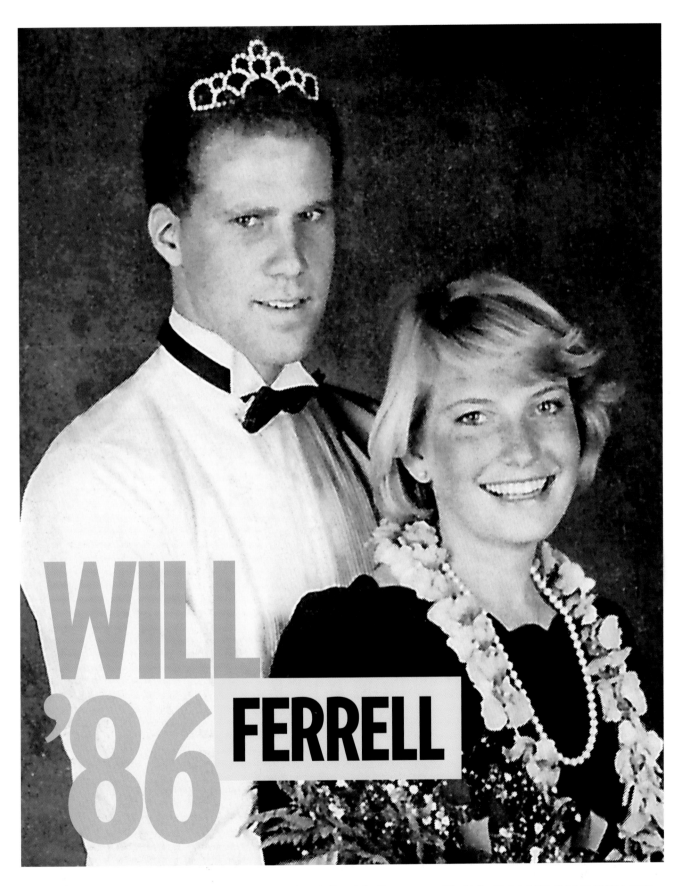

WILL FERRELL '86

HIGH SCHOOL: University High School, Irvine, Calif. **SNAKE SHORTAGE:** "I was a founding member of the Reptile Club. No one had a reptile. We had two meetings." **COMEDY ANXIETY:** "I wasn't a runaway. My parents weren't alcoholics. I thought, 'I'm not going to make it.'"

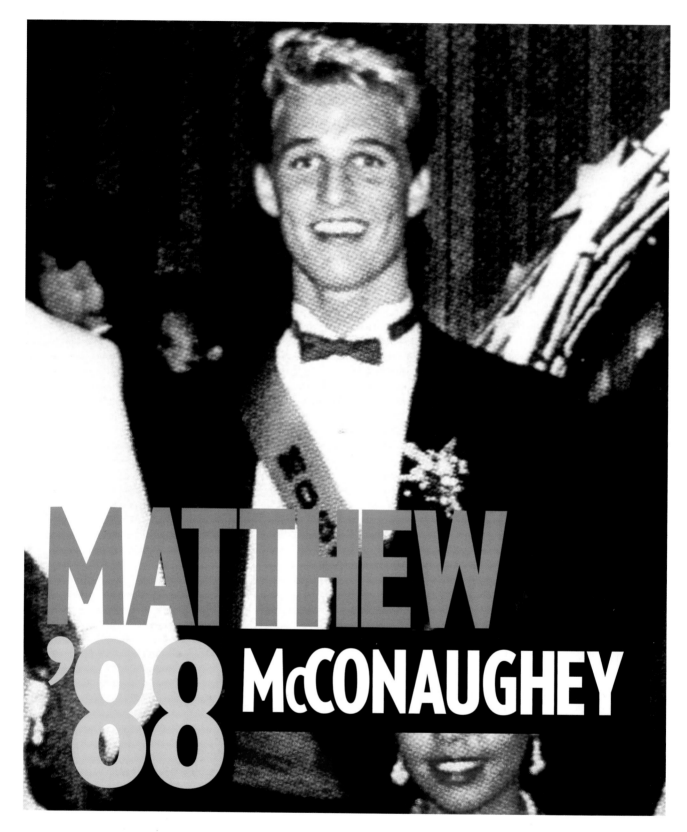

MATTHEW '88 McCONAUGHEY

HIGH SCHOOL: Longview High School, Longview, Texas **HEY, GOOD LOOKIN':** Voted Most Handsome long before he was PEOPLE's Sexiest Man Alive (2006). **BONGO-FREE ZONE:** McConaughey's parents pushed him to be a good student by keeping him at home to study while his friends were out on the town; considered law school before deciding to try film.

VINCE VAUGHN '88

HIGH SCHOOL: Lake Forest High School, Lake Forest, Ill. THE PEOPLE's CHOICE: Senior Class President CAREER CHANGE: Originally planned to be an athlete but switched to acting after a car crash damaged his thumb. OLD SCHOOL: Inducted into Lake Forest's Alumni Wall of Fame in 2005.

HEATHER GRAHAM '88

HIGH SCHOOL: Agoura High School, Agoura Hills, Calif. EXTRACURRICULAR: Graham was a self-described "theater geek." RULE BREAKER: Her strict FBI agent father and children's book author mother frowned on their daughter's interest in acting. Graham's turn as Rollergirl in 1997's *Boogie Nights* could've gotten her grounded.

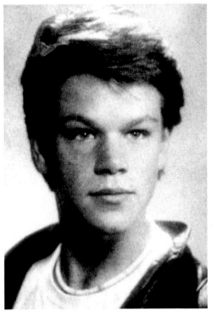

MATT DAMON '88

HIGH SCHOOL: Cambridge Rindge and Latin School, Cambridge, Mass. PLAN AHEAD: Damon and pal Ben Affleck starred in school plays, saved money for audition trips to Manhattan and, as Damon told *Interview*, held "business lunches" in the cafeteria.

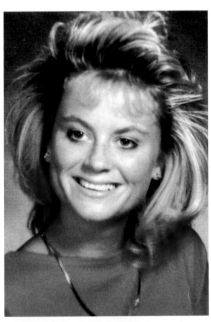

AMY POEHLER '88

HIGH SCHOOL: Burlington High School, Burlington, Mass. MS. POEHLER REGRETS: "Shoulder pads, parachute pants, acid-wash jean jackets, stirrup pants," she told *Seventeen*. "All of it was awful." RETROACTIVE ADVICE: "Put the hairspray down." ON DISCOVERING COMEDY: "The good thing about improv is you're never unprepared. Or, rather, always unprepared."

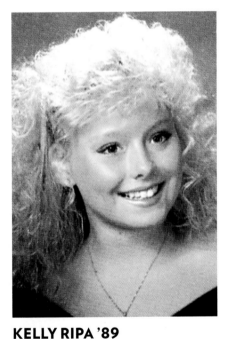

KELLY RIPA '89

HIGH SCHOOL: Eastern Regional High School, Voorhees, N.J. BATON PROFICIENCY? Yes. THE UPSIDE OF HAZING: Ripa has said that, in the long run, being teased in high school helped. "It prepared me for network TV, because after coming home from school every day crying over something some kid said, there's no producer or tabloid or network . . . that's really going to get to me."

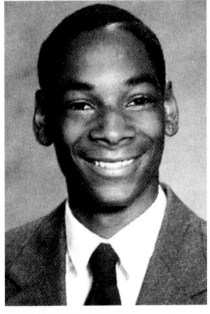

SNOOP DOGG '89

HIGH SCHOOL: David Starr Jordan High School, Long Beach, Calif. TEACHERS KNEW HIM AS: Cordazar Broadus QUOTE: "I'm pretty sure I bought weed from him"— former schoolmate Cameron Diaz. CLASS CLOWN? "I was fun to be around. Those m----------s knew me." PUPPY LOVE: Snoop Dogg is still married to his high school sweetheart Shante Taylor.

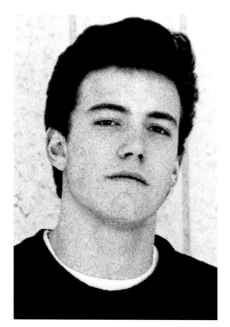

BEN AFFLECK '90

HIGH SCHOOL: Cambridge Rindge and Latin School, Cambridge, Mass. **BFF:** He and childhood pal Matt Damon took drama classes together. **HIGHER EDUCATION:** "I was into challenging everything and everybody and going to McDonald's between periods."

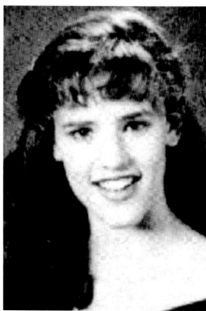

JENNIFER GARNER '90

HIGH SCHOOL: George Washington High School, Charleston, W.Va. **MEMORIES:** "I did well in classes that I loved. I played saxophone in the George Washington Patriots [marching] Band. I think it was a source of ridicule, but it didn't bother me. I was also into ballet."

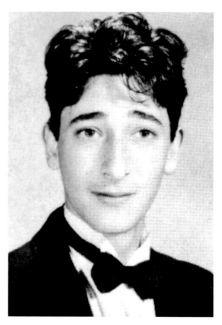

ADRIEN BRODY '91

HIGH SCHOOL: Fiorello H. LaGuardia High School for Music and Art and Performing Arts, New York City **SHOUT OUT:** In his Oscar acceptance speech (Best Actor for '02's *The Pianist*), Brody sent good wishes to high school buddy and Iraq War soldier Thomas Zarobinski. **WHAT HE PLAYED:** Basketball and hooky.

HILARY SWANK '91

HIGH SCHOOL: Sehome High School, Bellingham, Wash. (did not graduate). **EXTRACURRICULARS:** Gymnastics and swimming. **COMEBACK KID:** Swank once remarked that a few teachers discouraged her from acting. **THE ULTIMATE PAYBACK:** Two Oscars.

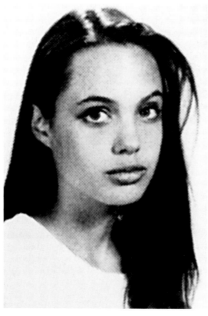

ANGELINA JOLIE '92

HIGH SCHOOL: Moreno High School, Beverly Hills **EARLY BIRD:** Graduated at 16. **MAD PUNK BALLROOM:** As a youth, took ballroom dancing lessons. **SHOP CLASS NOT OFFERED:** Expressed interest in becoming an undertaker. **A PENNY SAVED:** Her clothes came from thrift stores.

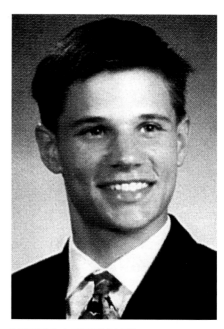

NICK LACHEY '92

HIGH SCHOOL: School for Creative & Performing Arts, Cincinnati **EARLY ROLE:** Lachey got his start in a stage production of *Peter Pan*, costarring classmate Carmen Electra. **WAY AFTER SCHOOL JOB:** Worked part-time delivering Chinese food after moving to Los Angeles.

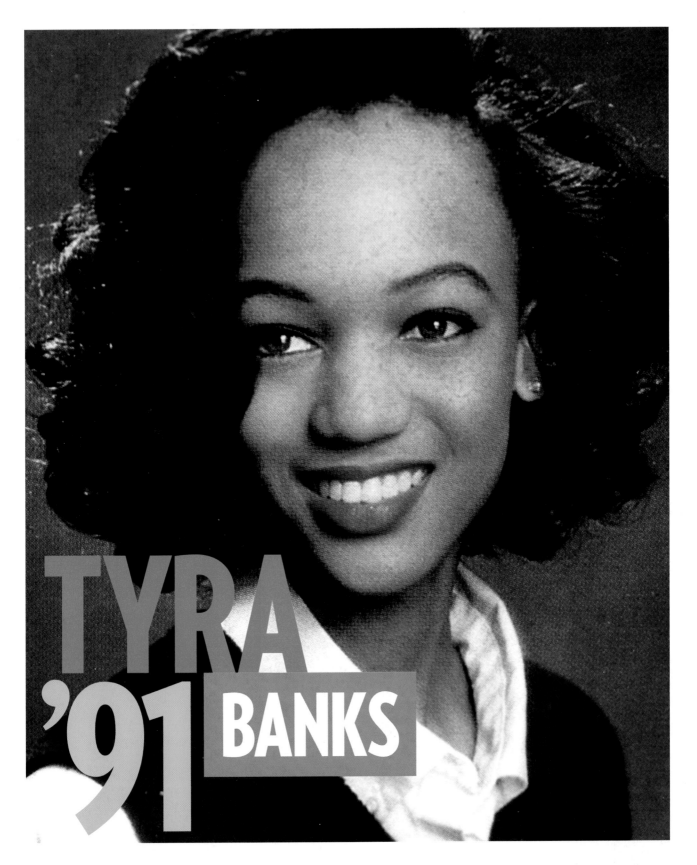

TYRA '91 BANKS

HIGH SCHOOL: Immaculate Heart, Los Angeles **AMERICA'S NEXT TOP ANIMAL DOCTOR:** Banks hoped to become a veterinarian. **MAKEUP ASSIGNMENT:** She and a friend would buy beauty products after class and vogue for the rest of the afternoon. "We thought we were so cool," says Banks. Not long after graduation, she strutted the runways in Paris.

SEANN WILLIAM '95 SCOTT

HIGH SCHOOL: Park High School, Cottage Grove, Minn. **GOT THE PROM KING VOTE BECAUSE:** "I was lucky enough to have a lot of cool friends." **THAT SAID:** "I didn't, uh, talk to girls that well. I was pretty pathetic." **COOL REAL-WORLD MOVE:** "I was able to pay for my dad to retire," he told the *Los Angeles Times.* "He worked at a 3M plant making Scotch tape."

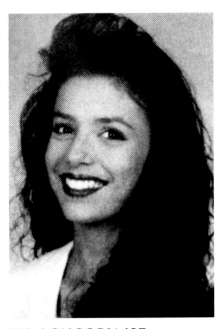

EVA LONGORIA '93

HIGH SCHOOL: Roy Miller High School, Corpus Christi, Texas **WELL-BEHAVED:** Says she was definitely not a class cutup. **LET'S GET PHYSICAL:** A cheerleader in high school, Longoria went on to get a degree in kinesiology from Texas A&M University and to be crowned Miss Corpus Christi USA.

BRADLEY COOPER '93

HIGH SCHOOL: Germantown Academy, Fort Washington, Pa. **STRONG:** Weight-lifting club **BUT SENSITIVE:** Poetry club **IN FACT, IS THERE ANYTHING THIS MAN CANNOT DO?** Cross country; tennis (captain); basketball; baseball; business club; newspaper; and Latin club. Hail, Cooper!

CHELSEA HANDLER '93

HIGH SCHOOL: Livingston High School, Livingston, N.J. **TREND:** "We had a lot of big hair going on. I looked like the Lion King." **YEARBOOK QUOTE:** "Friendship may . . . grow into love, but love never subsides into friendship."—Lord Byron **HONEST ABOUT A SENSITIVE TOPIC:** "I had an abortion at 16," she has said. "Because that's what I should have done."

REESE WITHERSPOON '94

HIGH SCHOOL: The Harpeth Hall School, Nashville, Tenn. **NICKNAME:** "Big Words" **AFTER-SCHOOL JOB:** The Nashville debutante, who made seven movies before graduation, worked as a production assistant on *Devil in a Blue Dress* for class credit.

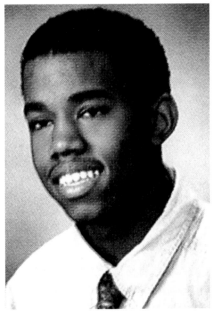

KANYE WEST '95

HIGH SCHOOL: Polaris School for Individual Education, Oak Lawn, Ill. **ON MUSIC:** "I really feel that it saved me in high school. It kept me out of the streets. It kept me from getting into trouble. It gave me something to do when I got kicked off the basketball team." **HOMEWORK HELP?** His mom was chairman of the English department at Chicago State University in Chicago. **PROOF HE WAS SPECIAL?** "I grew up to be me."

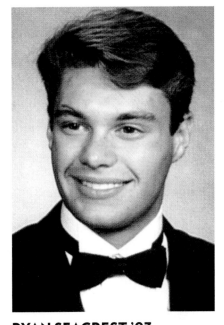

RYAN SEACREST '93

HIGH SCHOOL: Dunwoody High School, Dunwoody, Ga. **DISCIPLINE!** Football practice "was intense. You couldn't even think about missing a second." **AND CHUTZPAH!** At 16, he talked his way into the offices of WSTR-FM. Later, when a deejay fell ill, he handed the teenager the mic. "We thought the boss was out of town," says Seacrest. He wasn't, but liked what he heard and began giving Seacrest work.

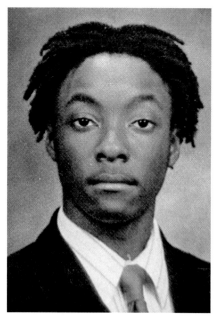

WILL.I.AM '93

HIGH SCHOOL: Palisades High School, Pacific Palisades, Calif. GREW UP IN: An East L.A. housing project. PALS KNEW HIM AS: William James Adams Jr. H.S. BEST BUDDY: Allan Pineda Lindo, now the Black Eyed Peas' apl.de.ap. SHOUT OUT TO HIS MOM, DEBRA, WHO KEPT HIM OUT OF TROUBLE: "The most beautiful woman in the world. She is dope."

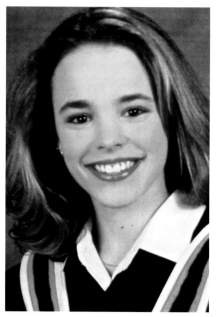

RACHEL McADAMS '97

HIGH SCHOOL: Central Elgin Collegiate Institute, St. Thomas, Ont. ONE IS THE LONELIEST NUMBER: "High school was hard. I didn't have a group, I had me." ACTING UP: She joined a theater program at 12 and said, "I was absolutely terrified . . . [and] would run home crying to my parents."

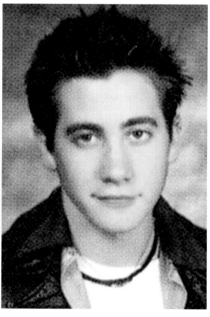

JAKE GYLLENHAAL '98

HIGH SCHOOL: Harvard-Westlake School, North Hollywood, Calif. SOPHISTICATED SOUNDS: Madrigal singer BACK TO WORK: High school represented a bit of a break for Gyllenhaal, who landed his first film role at 10 as Billy Crystal's son in *City Slickers*. He began auditioning again during his junior year and filmed the starring role in *October Sky* while a senior.

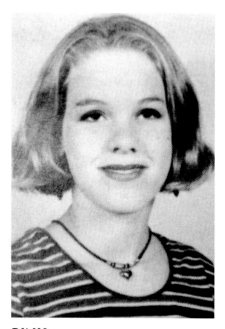

PINK

HIGH SCHOOL: Central Bucks High School West, Doylestown, Pa. TOO COOL FOR SCHOOL: The former Alecia Moore (above, in eighth grade) dropped out, got her GED and went on to liberate herself from past spelling lessons with 2001's *M!ssundaztood*. LOOKING BACK: "I'm still that little punk," she said.

LEONARDO DiCAPRIO

HIGH SCHOOL: John Marshall High School, Los Feliz, Calif. (Did not graduate.) QUOTE: "I was frustrated in school. I wasn't happily learning things. . . . I could never focus on things I didn't want to learn," DiCaprio told *Teen*. "I used to do break-dancing skits with my friend at lunchtime."

KEIRA KNIGHTLEY '01

HIGH SCHOOL: Teddington School, Teddington, England MULTITASKING: Juggled school and work and appeared in her first blockbuster, albeit briefly, as Natalie Portman's lookalike "decoy" in 1999's *Star Wars: Episode I—The Phantom Menace*. HIGH SCHOOL WOES: Claims she was not very popular.

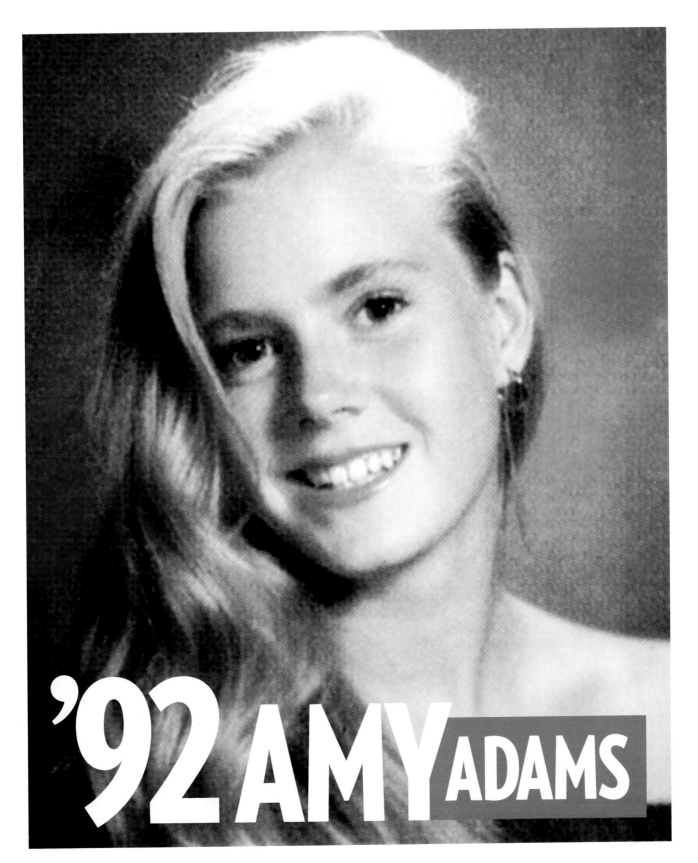

'92 AMY ADAMS

HIGH SCHOOL: Douglas County High School, Castle Rock, Colo. **TOUGH CRITIC!** "I was homely, painfully small, [usually] with too much blue eye shadow," she told *Allure.* **PICKED SHOWBIZ OVER MEDICINE BECAUSE?** "I couldn't pass chemistry. Couldn't do math. Still can't." **LATER WORKED AS?** Hooters waitress; Gap greeter: "I couldn't help but smile at people."

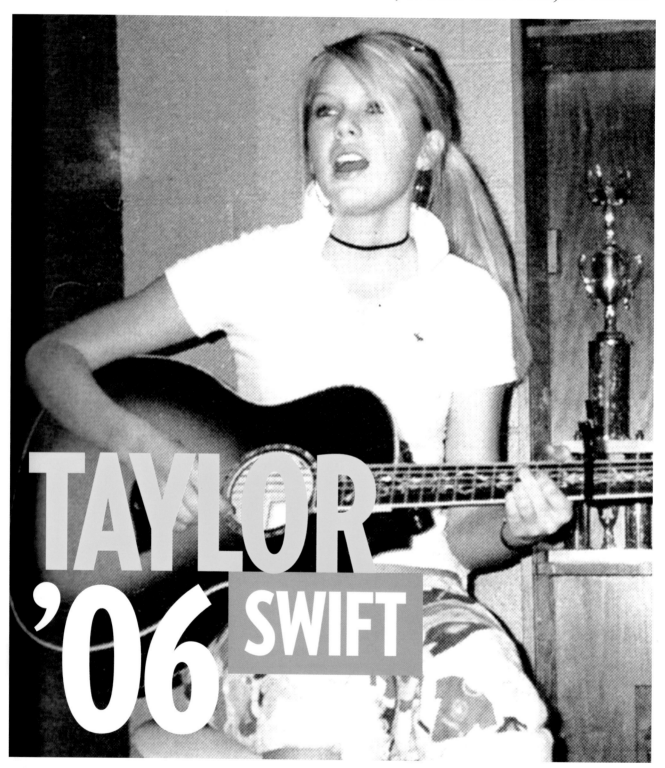

TAYLOR SWIFT '06

HIGH SCHOOL: Hendersonville H.S., Hendersonville, Tenn. **BUT ONLY:** For 9th and 10th grade. After that she hit the road to perform and switched to a private school that offered flexibility. **MEMORY?** "Getting asked to the prom two days before, buying a $40 dress and having the time of my life." **WHAT'S THAT IN THE MAILBOX?** Her diploma (she missed graduation).

KATY PERRY '00

HIGH SCHOOL: **Dos Pueblos High, Goleta, Calif.** THEY KNEW HER AS: **Katheryn Hudson** BUT THEY DIDN'T KNOW HER FOR LONG: **She left after her freshman year.** THE BIG SWITCH: **Raised in a strict Christian household, she released her first album, of gospel music, at 16, before re-emerging as a pop princess seven years later.**

CARRIE UNDERWOOD '01

HIGH SCHOOL: **Checotah High School, Checotah, Okla.** ACADEMIC ACHIEVEMENT: **Class Salutatorian** GANG AFFILIATION? **"We were definitely the good kids. We'd all go to church together. Prom night we all went over to my friend's house and drank nonalcoholic champagne."**

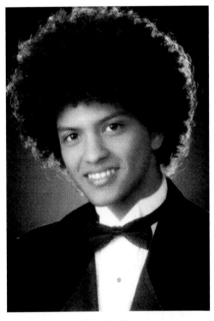

BRUNO MARS '03

HIGH SCHOOL: **Theodore Roosevelt High School, Honolulu** A HUNKA HUNKA TALENTED TYKE: **At 6, Mars played an Elvis impersonator in** *Honeymoon in Vegas.* HIGH SCHOOL HABIT: **"I rarely saw him with a book," says his dad, "but he always had a guitar or ukulele."**

KELLAN LUTZ '03

HIGH SCHOOL: **Horizon High School, Scottsdale, Ariz.** VERY ACTIVE: **Varsity football; French club; Latin club; Spanish Honorary Society; boxing** GOOD AT MATH! **Teased a friend who had taken a modeling job—until the friend said, "I made $500 in one day." Lutz, 14, sent pix to an agency and got work.**

ADAM LAMBERT '00

HIGH SCHOOL: **Mount Carmel High School, San Diego** FRUSTRATED FLAMBOYANCE: **"I never wore full-on eyeliner in high school, but I wanted to."** ON BEING CLOSETED: **"In high school . . . you have your first date and your first love, your first kiss. I didn't have any of that."**

KE$HA SEBERT '05

HIGH SCHOOL: **Brentwood High School, Brentwood, Tenn.** OUT OF TOWN: **When Ke$ha began traveling for her career during her senior year, says her mom, the school "didn't seem to be open to working with us."** UPSHOT: **Ke$ha received her degree elsewhere, and her folks held a graduation ceremony in their home.**

I WAS A TEENAGE
DRAMA GEEK!

Jocks? Schmocks! Real courage meant dressing up as Humpty and putting on a show in front of your peers

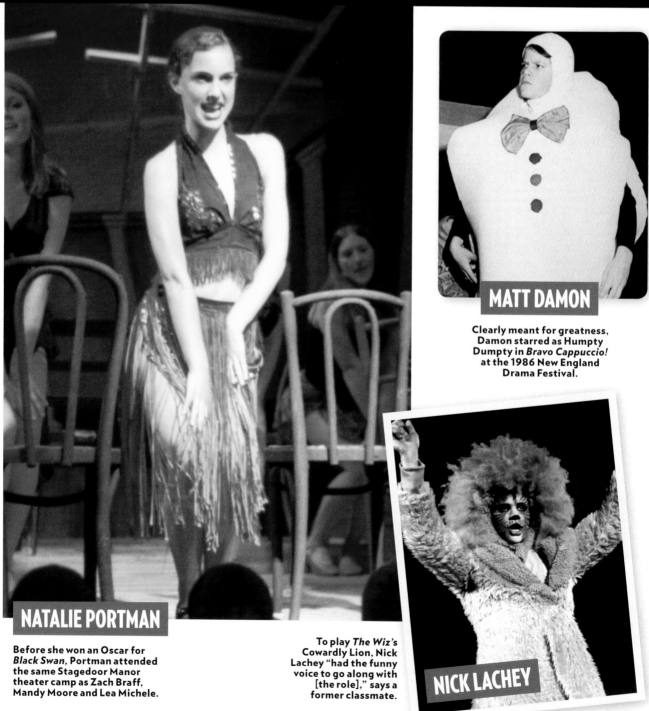

MATT DAMON

Clearly meant for greatness, Damon starred as Humpty Dumpty in *Bravo Cappuccio!* at the 1986 New England Drama Festival.

NATALIE PORTMAN

Before she won an Oscar for *Black Swan*, Portman attended the same Stagedoor Manor theater camp as Zach Braff, Mandy Moore and Lea Michele.

To play *The Wiz*'s Cowardly Lion, Nick Lachey "had the funny voice to go along with [the role]," says a former classmate.

NICK LACHEY

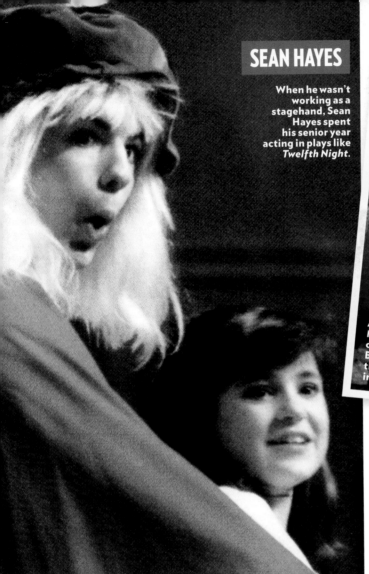

SEAN HAYES

When he wasn't working as a stagehand, Sean Hayes spent his senior year acting in plays like *Twelfth Night*.

ZACH BRAFF

At Stagedoor Manor theater camp in 1988, Braff took on the role of Judas in *Godspell*.

JUDE LAW

Jude Law stole the show during *Joseph and the Amazing Technicolour Dreamcoat* at the 1989 Edinburgh Festival.

BLAKE LIVELY

Lively and curvaceous, the future Gossip Girl goofs around at Burbank High. Initially cool to acting, she later got excited by, among other things, the "free food."

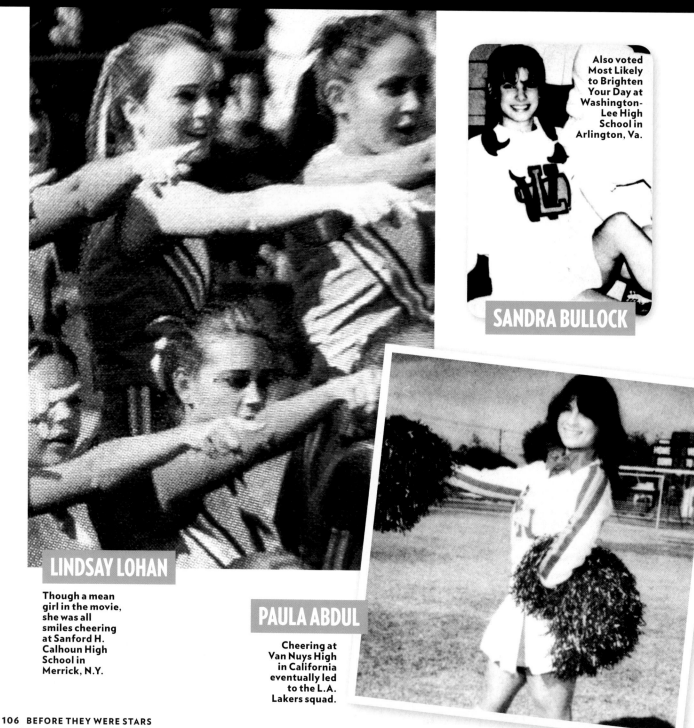

SSS! BOOM! BAH!
CHEERLEADERS

Rare, it might seem, is the female celebrity without a baton or pom-poms in her past

Also voted Most Likely to Brighten Your Day at Washington-Lee High School in Arlington, Va.

SANDRA BULLOCK

LINDSAY LOHAN

Though a mean girl in the movie, she was all smiles cheering at Sanford H. Calhoun High School in Merrick, N.Y.

PAULA ABDUL

Cheering at Van Nuys High in California eventually led to the L.A. Lakers squad.

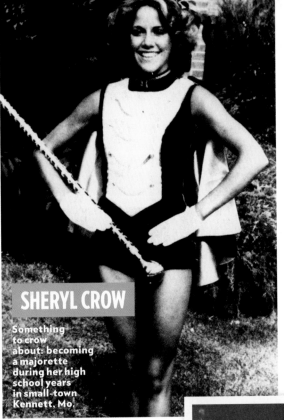

SHERYL CROW

Something to crow about: becoming a majorette during her high school years in small-town Kennett, Mo.

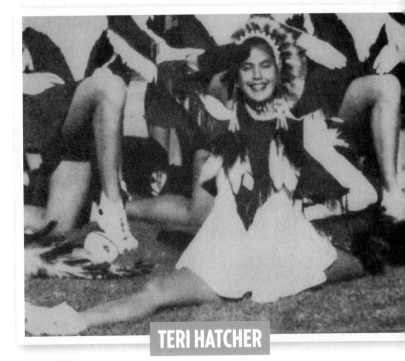

TERI HATCHER

Joined the cheerleading squad at Fremont High School in Sunnyvale, Calif.

REESE WITHERSPOON

Played the southern belle as a cheerleader at Nashville's Harpeth Hall School.

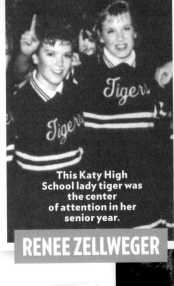

This Katy High School lady tiger was the center of attention in her senior year.

RENEE ZELLWEGER

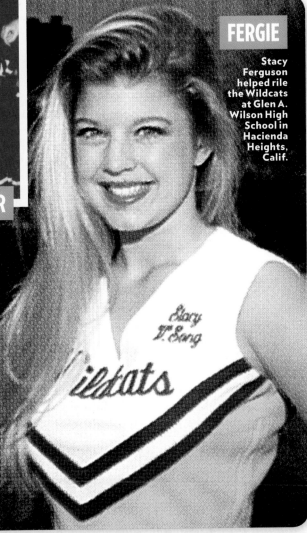

FERGIE

Stacy Ferguson helped rile the Wildcats at Glen A. Wilson High School in Hacienda Heights, Calif.

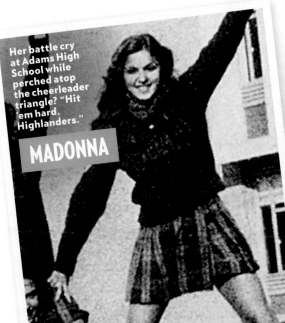

Her battle cry at Adams High School while perched atop the cheerleader triangle? "Hit 'em hard, Highlanders."

MADONNA

SWEAT & CHEERS

GO TEAM!

One led her team to two state championships;
George Clooney, though, was a beautiful loser

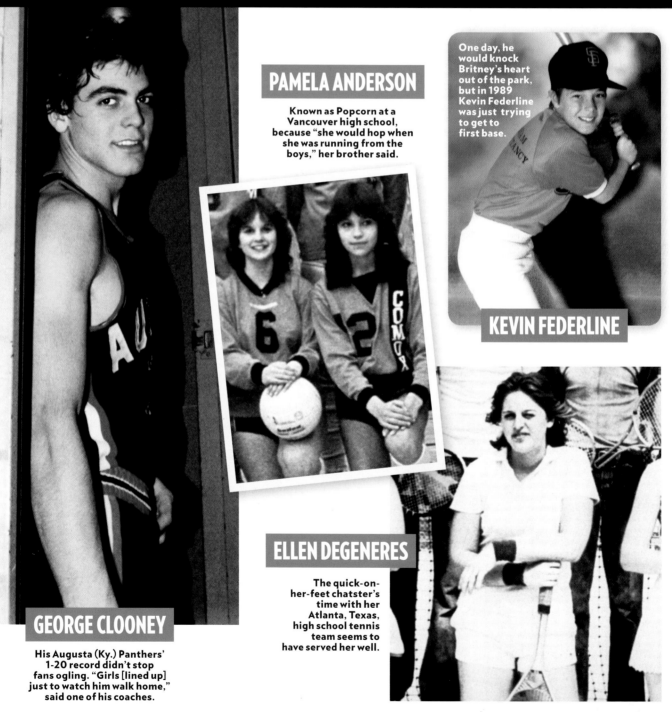

PAMELA ANDERSON

Known as Popcorn at a
Vancouver high school,
because "she would hop when
she was running from the
boys," her brother said.

One day, he
would knock
Britney's heart
out of the park,
but in 1989
Kevin Federline
was just trying
to get to
first base.

KEVIN FEDERLINE

GEORGE CLOONEY

His Augusta (Ky.) Panthers'
1-20 record didn't stop
fans ogling. "Girls [lined up]
just to watch him walk home,"
said one of his coaches.

ELLEN DEGENERES

The quick-on-
her-feet chatster's
time with her
Atlanta, Texas,
high school tennis
team seems to
have served her well.

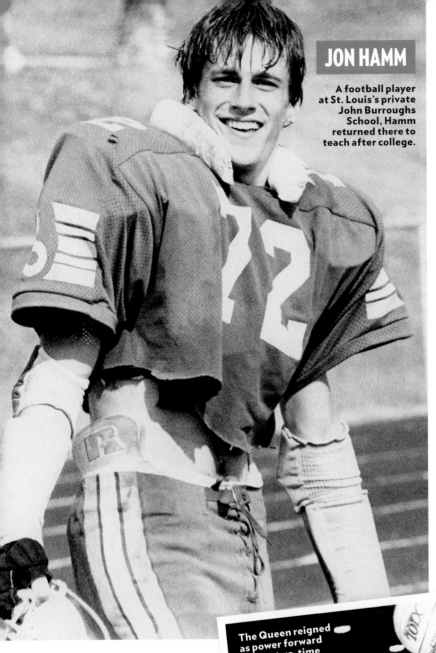

JON HAMM

A football player at St. Louis's private John Burroughs School, Hamm returned there to teach after college.

KENNY CHESNEY

"I loved playing but quit growing," said the Gibbs High (Tenn.) receiver. "I weighed 140 soaking wet."

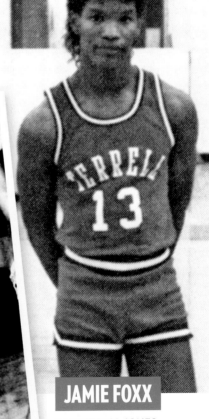

JAMIE FOXX

BASKETBALL JONES: The former Texas high school player would later shoot hoops, for fun, with Shaquille O'Neal.

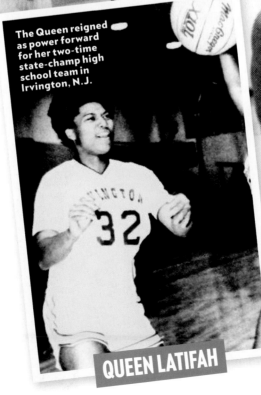

The Queen reigned as power forward for her two-time state-champ high school team in Irvington, N.J.

QUEEN LATIFAH

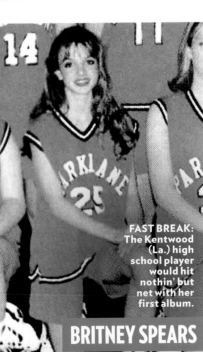

FAST BREAK: The Kentwood (La.) high school player would hit nothin' but net with her first album.

BRITNEY SPEARS

BEFORE THEY WERE
GLEEKS!

In school the cast of *Glee* was often like the kids on *Glee*

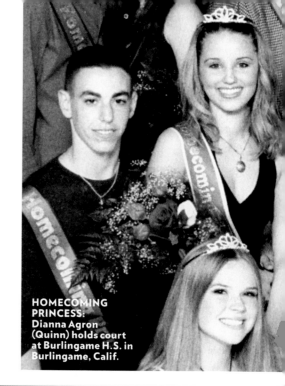

HOMECOMING PRINCESS: Dianna Agron (Quinn) holds court at Burlingame H.S. in Burlingame, Calif.

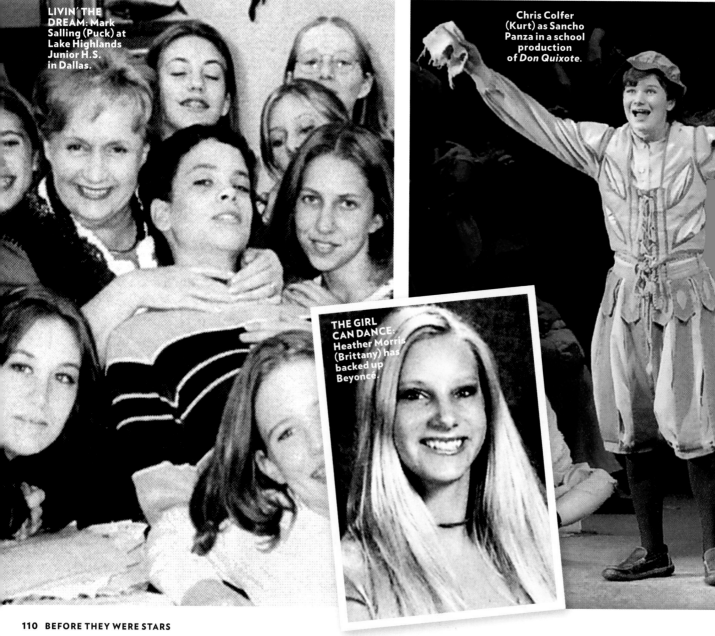

LIVIN' THE DREAM: Mark Salling (Puck) at Lake Highlands Junior H.S. in Dallas.

Chris Colfer (Kurt) as Sancho Panza in a school production of *Don Quixote*.

THE GIRL CAN DANCE: Heather Morris (Brittany) has backed up Beyoncé.

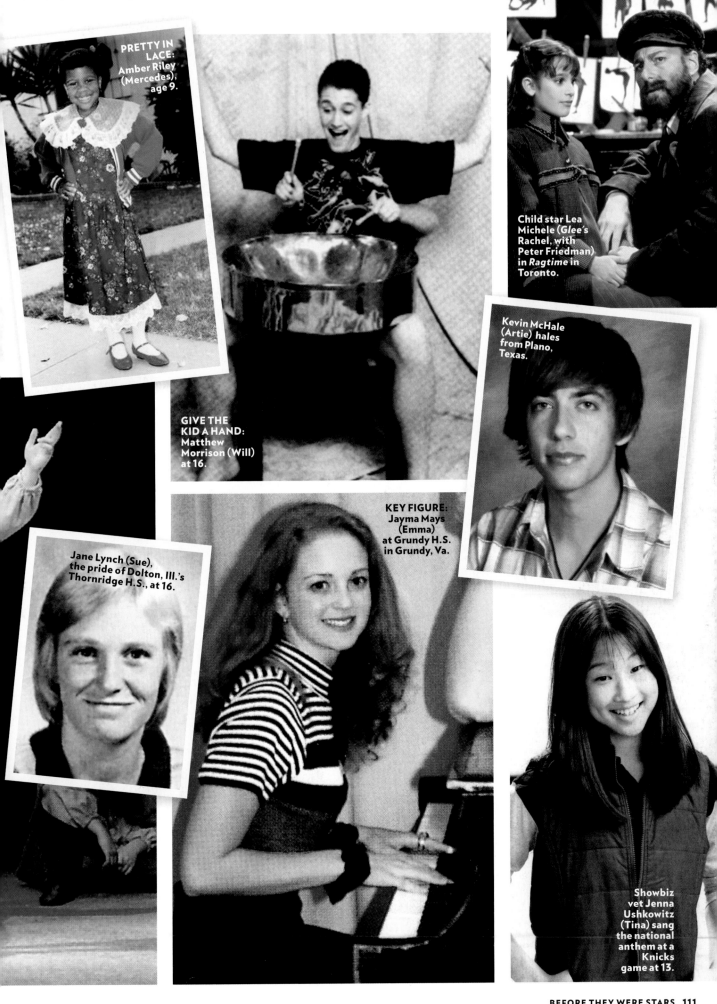

PRETTY IN LACE: Amber Riley (Mercedes), age 9.

Child star Lea Michele (*Glee's* Rachel, with Peter Friedman) in *Ragtime* in Toronto.

Kevin McHale (Artie) hales from Plano, Texas.

GIVE THE KID A HAND: Matthew Morrison (Will) at 16.

KEY FIGURE: Jayma Mays (Emma) at Grundy H.S. in Grundy, Va.

Jane Lynch (Sue), the pride of Dolton, Ill.'s Thornridge H.S., at 16.

Showbiz vet Jenna Ushkowitz (Tina) sang the national anthem at a Knicks game at 13.

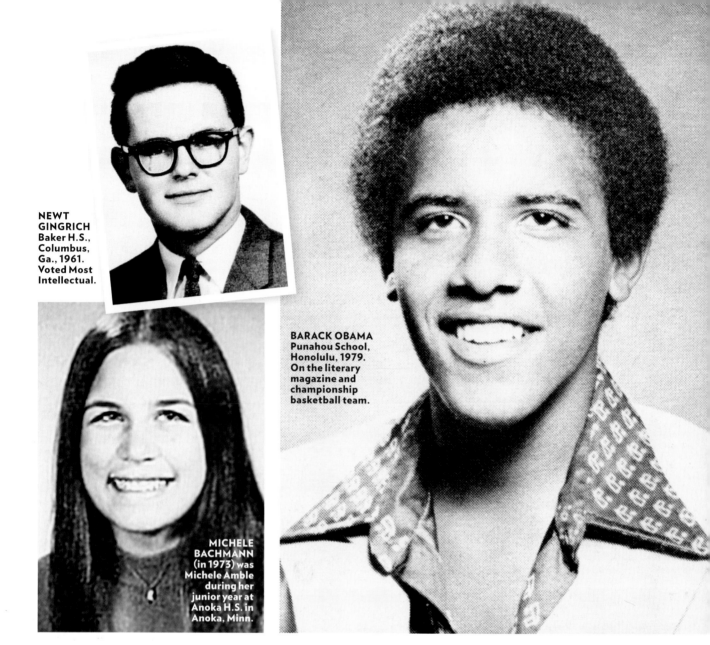

NEWT GINGRICH Baker H.S., Columbus, Ga., 1961. Voted Most Intellectual.

BARACK OBAMA Punahou School, Honolulu, 1979. On the literary magazine and championship basketball team.

MICHELE BACHMANN (in 1973) was Michele Amble during her junior year at Anoka H.S. in Anoka, Minn.

POLLS & PUNDITS

Back then, Hawaii's Barack Obama was just a senior with a collar as big as his dreams

JOHN BOEHNER Moeller High School, Cincinnati, 1968. Varsity football; Greater Cincinnati Safety League; and Catholic Student's Mission Crusade.

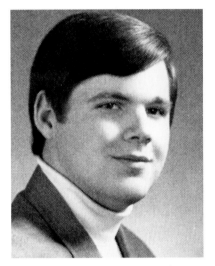

RUSTY LIMBAUGH Said school (Cape Girardeau, Mo., 1969) felt like "prison"

WILLARD MITT ROMNEY Cranbrook School, Bloomfield Hills, Minn., 1965. Glee; hockey (manager).

GLENN BECK Sehome High School, Bellingham, Wash., 1982.

TWO GUYS WITH TONY DANZA'S HAIR!

On the left, though he's now more to the right, that's former Minnesota governor Tim Pawlenty (South St. Paul H.S., South St. Paul, Minn., 1979). To the right, but in real life to the left, is *The Daily Show*'s Jon Stewart, who in high school (Lawrenceville H.S., Lawrenceville, N.J., 1980) was a soccer star and "very into Eugene Debs."

STEPHEN COLBERT Porter-Gaud School, Charleston, S.C., 1982. French club!

I WANNA ROCK WITH YOU

Put it this way:
These are the
kids you didn't
want to run up
against at the
local talent show

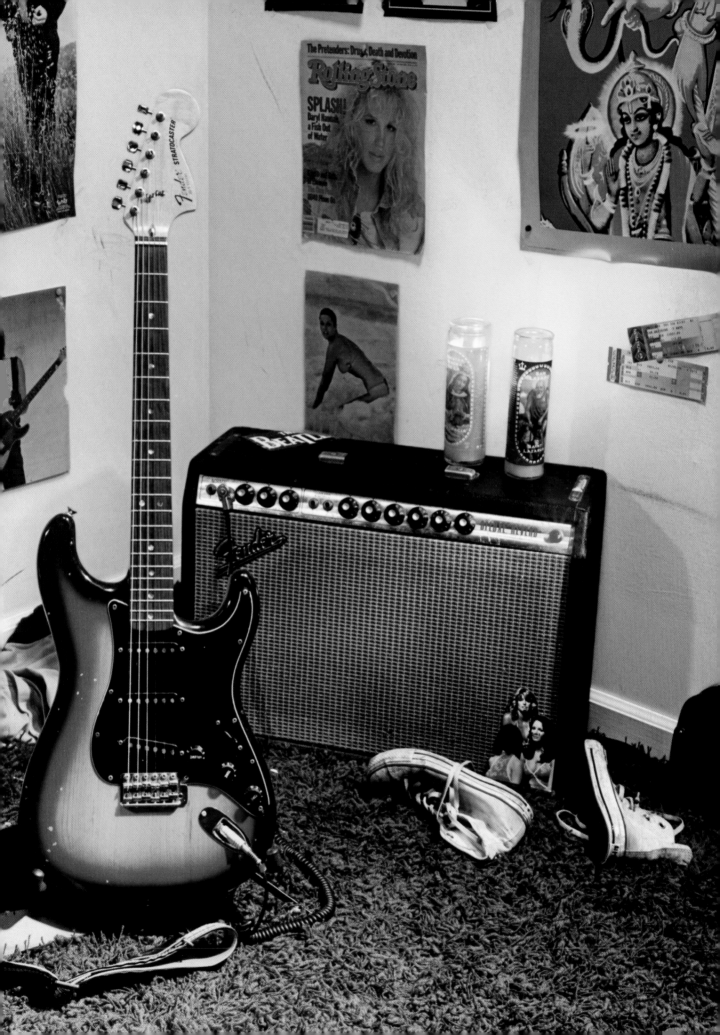

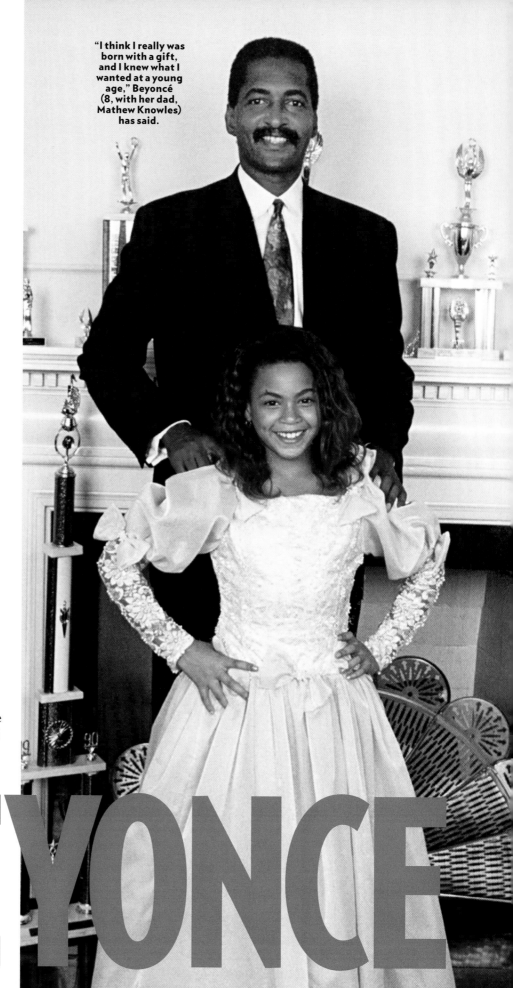

Her dad, a Houston Xerox executive, and her mom, a hair salon owner, sent 7-year-old Beyoncé to dance class to overcome shyness. It worked. Two years later she led a Supremes-inspired group, Girls Tyme, all the way to *Star Search*. It took her eight years to return to the limelight with Destiny's Child—but she came back with a bang, writing and producing many of the group's hits. Now that the world can say her name, are there any skeletons in her childhood closet? Nope: "I've had a very healthy childhood and happy memories."

BEYONCE

JUSTIN
TIMBERLAKE

You want charm? Justin Timberlake is certified. At age 11, he won $16,000 in savings bonds at Nashville's Universal Charm Pageant, the first boy to capture a local prize traditionally awarded to girls. "As a child, I had such a love for music," said Timberlake, who sang for three years in a Baptist church choir. "There was a music program [in my school], but it was stupid. If it wasn't for me urging my mom to let me go to voice lessons and to let me do talent shows, I would never have been here." Here being, of course, center stage.

EMINEM

Raised in a working-class suburb of Detroit, Marshall Mathers dropped out of high school after ninth grade. It wasn't until he discovered rap—and became one of the few white kids on Detroit's rap circuit—that he found his calling. "At the end of the day hip-hop is about brainpower," said Mathers, who soon adopted the name Eminem. "It's brain versus brain. It's about who can outsmart who."

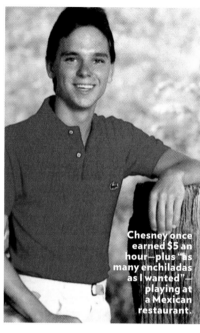

Chesney once earned $5 an hour—plus "as many enchiladas as I wanted"— playing at a Mexican restaurant.

KENNY
CHESNEY

Long before his breakout hit "She Thinks My Tractor's Sexy" led to a gold record and a brief marriage to Renée Zellweger, Kenny Chesney preferred football to music. But when his mom gave him a guitar for Christmas, Chesney joined a bluegrass band and started writing songs. After getting a marketing degree at East Tennessee State University, he headed to Nashville. Yep, he was nervous at first. "I could sing," he said, "but my hands were shaking so bad that I couldn't play guitar."

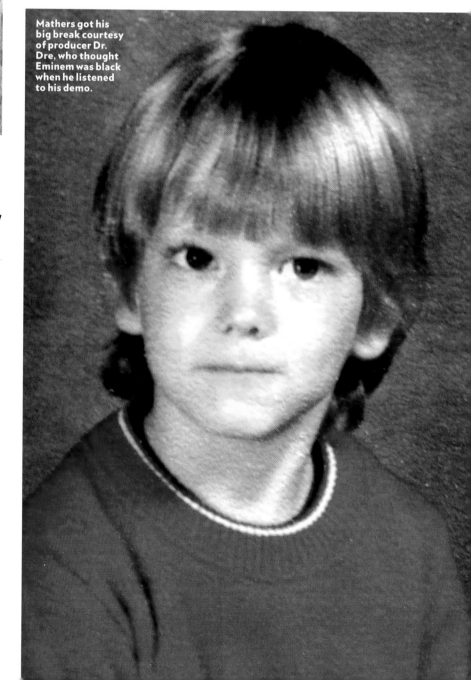

Mathers got his big break courtesy of producer Dr. Dre, who thought Eminem was black when he listened to his demo.

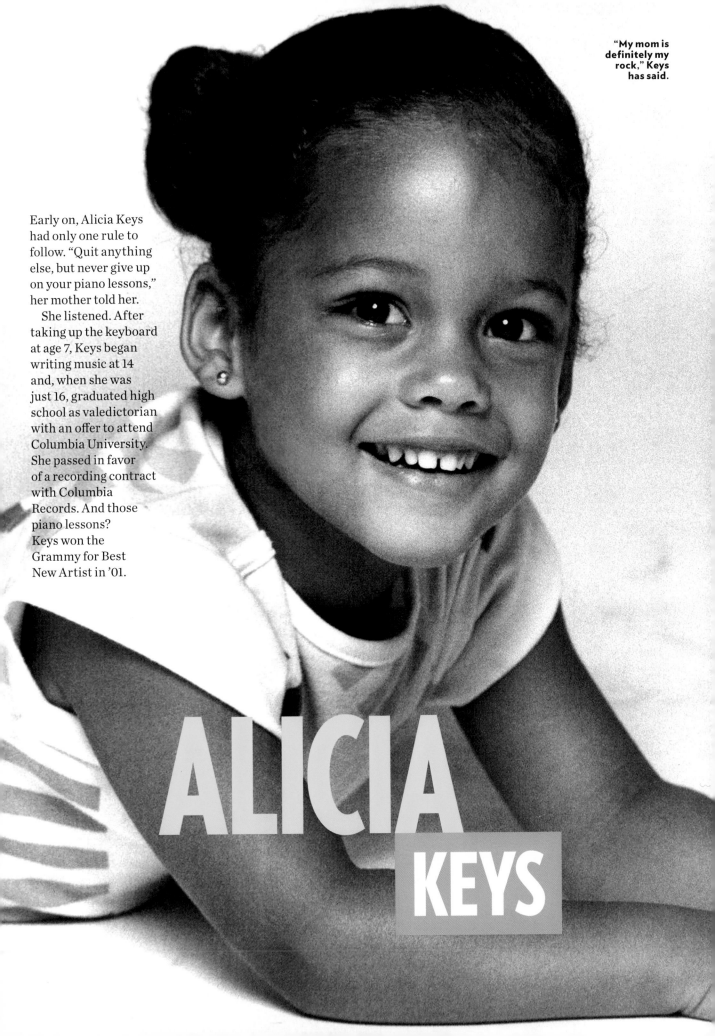

"My mom is definitely my rock," Keys has said.

Early on, Alicia Keys had only one rule to follow. "Quit anything else, but never give up on your piano lessons," her mother told her.

She listened. After taking up the keyboard at age 7, Keys began writing music at 14 and, when she was just 16, graduated high school as valedictorian with an offer to attend Columbia University. She passed in favor of a recording contract with Columbia Records. And those piano lessons? Keys won the Grammy for Best New Artist in '01.

ALICIA
KEYS

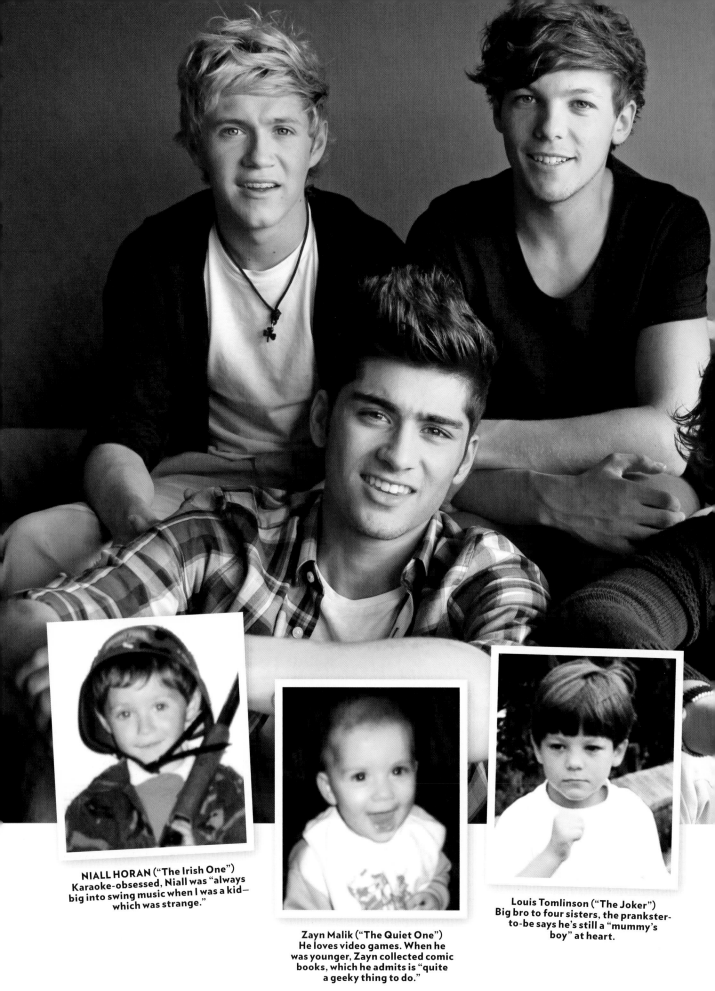

NIALL HORAN ("The Irish One")
Karaoke-obsessed, Niall was "always big into swing music when I was a kid—which was strange."

Zayn Malik ("The Quiet One")
He loves video games. When he was younger, Zayn collected comic books, which he admits is "quite a geeky thing to do."

Louis Tomlinson ("The Joker")
Big bro to four sisters, the prankster-to-be says he's still a "mummy's boy" at heart.

ONE DIRECTION

Harry (squeal!), Zayn (sob!), Niall (screech!), Liam (wail!) and Louis (cry of teen despair!) rule the boy-band world

Before the tween meltdowns and gazillion YouTube hits, they were just supercute small-town lads who dreamed of finding solo stardom via Britain's *X Factor*. Harry Styles had never set foot in London. Zayn Malik was a star in high school musicals but freaked out about stepping before the cameras. Niall Horman grew up in an Irish town so small that he sang to have something to do. Liam Payne, who overcame a serious medical issue as a kid, juggled music and sports and nearly became an Olympic runner. Only Louis Tomlinson had a whiff of professional experience, as an extra on TV.

As soloists each boy struck out. What they hadn't counted on was the sixth sense of *X* judge Simon Cowell, who saw quintet potential. "When I saw them standing there for the first time as a group, something clicked," he said, and he gave them another shot on the show. 1D, as they became known to fans, still didn't win, but Cowell scooped them up for his record label.

Boy-bandemonium struck like lightning; many U.S. fans had Twittered and Facebooked 1D long before they became international celebs. As a result their debut album, *Up All Night*, was No. 1 as soon as it was released in March— a history-making feat for a British group that even the Beatles couldn't match.

Now that the hottest boy band on the planet sells out stadiums in minutes, will they forget their humble roots? So far, at least, their perfectly tousled heads still seem to be on straight. "We're five normal lads," says Zayn. "We're not massively ripped, we don't have amazing bodies and we freely admit we can't dance."

LIAM PAYNE ("The Sensible One")
1D's star athlete, Liam learned how to box when he was bullied at school.

HARRY STYLES ("The Flirt")
"I always used to love singing," says Styles, who jammed with his high school band White Eskimo.

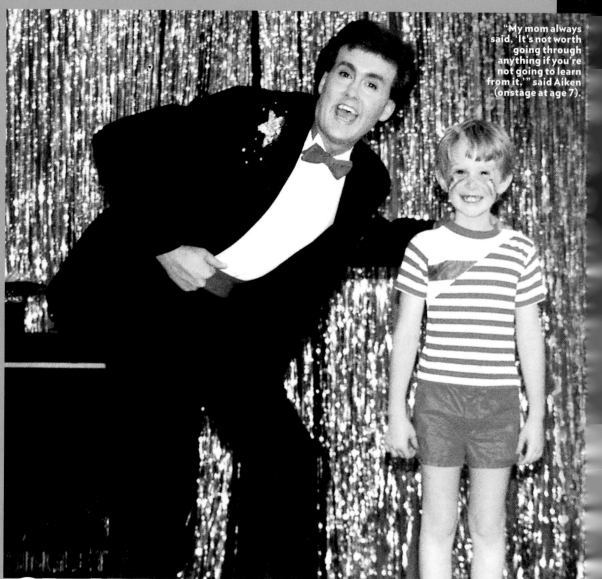

CLAY AIKEN

"I was dubbed the Loser throughout most of my childhood," Clay Aiken once said. Growing up in Raleigh, N.C., Aiken was a self-described "insult magnet, a nerd who loved his grandparents, who wore the wrong clothes, who liked the wrong things, who had goofy hair and glasses." But it was just that goofy look that people came to love on Season 2 of *American Idol,* when he was voted a close runner-up to winner Ruben Studdard. The lesson? "I think it's not just about whether you wear the right clothes."

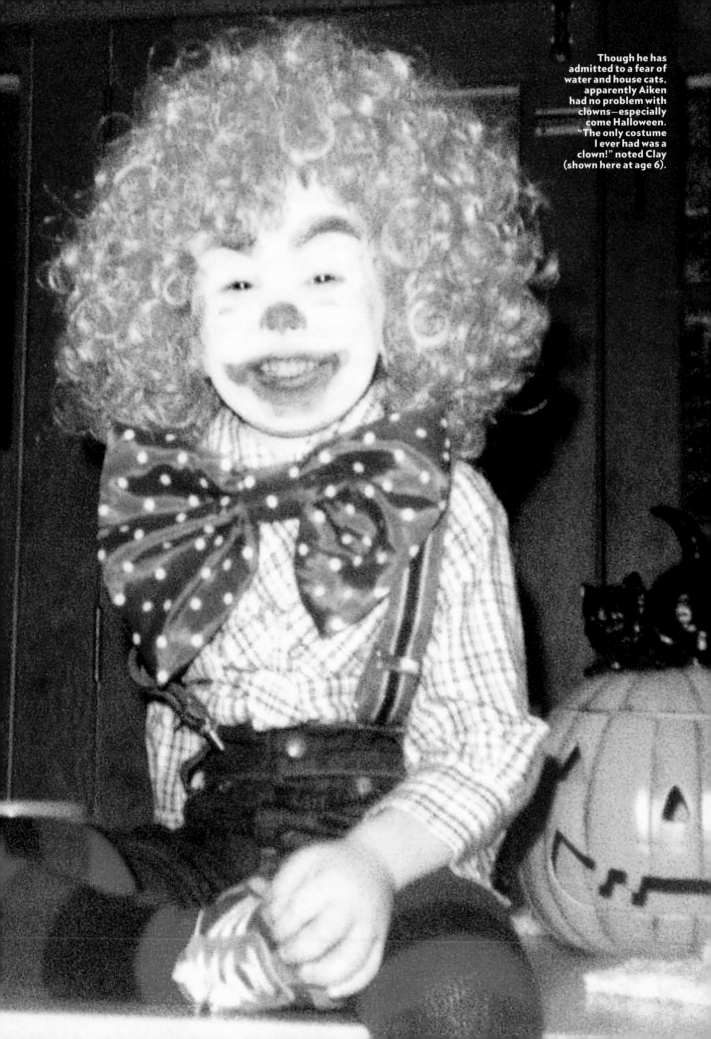

Though he has admitted to a fear of water and house cats, apparently Aiken had no problem with clowns—especially come Halloween. "The only costume I ever had was a clown!" noted Clay (shown here at age 6).

TINY AND TALENTED

Jamie Foxx played piano, Keith Urban plucked a ukulele, Lance Armstrong rode a Schwinn—baby steps that led to the Big Time

JAMIE FOXX

He started piano lessons when he was 5 and at 15 entered a youth talent competition. "He was singing, and the women just moved to the front to be near him," recalls childhood pal Chris Barron. "He had that magnetism." He also earned $75 per week as the accompanist and choir leader to the New Hope Baptist Church choir. "Music was the means to everything," he said. *Ray* Oscar included.

KEITH URBAN

In Caboolture, Australia, Keith Urban started on the ukulele at age 3 and traded up to a guitar by age 6. The Dolly Parton fan had a budding career by the time he hit high school. His big break? A $50 gig playing at an outdoor music festival.

USHER

By age 9, Usher Raymond IV knew his "spirit was attracted to music." He sang in his mother's Chattanooga, Tenn., church choir, won talent shows, joined a singing group (under the stage name Cha Cha) and, at age 12, moved to Atlanta to pursue a music career. Says Usher: "I was born to do what I do."

CAMERON DIAZ

She had a musical number in *The Mask,* but Cameron Diaz is better known for bad karaoke, both in *My Best Friend's Wedding* and as a youngster. "Everyone has a gift," she once said. "A great singing voice isn't mine."

LANCE
ARMSTRONG

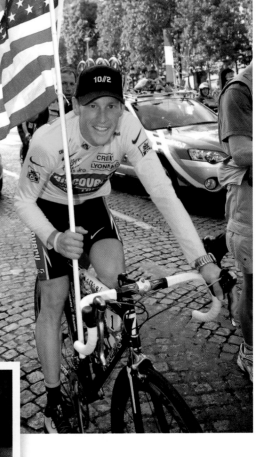

Growing up across the street from a bike shop in Richardson, Texas, Lance Armstrong had two-wheelers on the brain. At 7, the future seven-time Tour de France champ got his first "serious" bike, a Schwinn Mag Scrambler, and pedaled to school instead of riding with Mom. "Why does a kid love a bike?" Armstrong wrote in his 2000 memoir *It's Not About the Bike.* "It's liberation and independence."

I'M WITH THE MOUSE!

A stint on *The New Mickey Mouse Club* (1989-1994) could be the express lane to fame: Check out the class of 1993

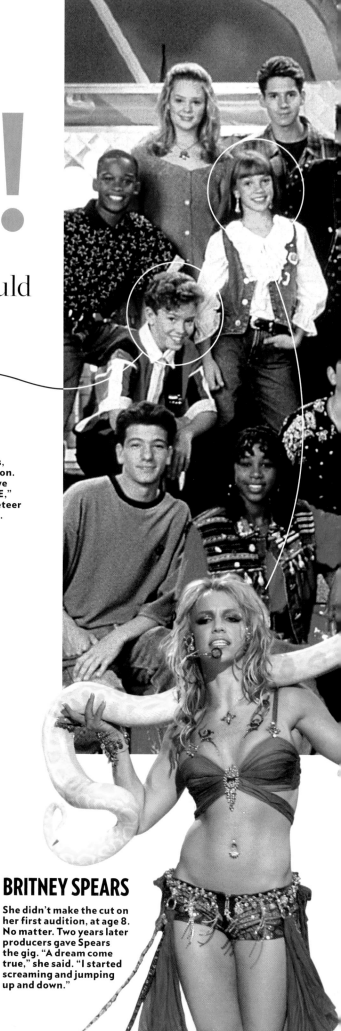

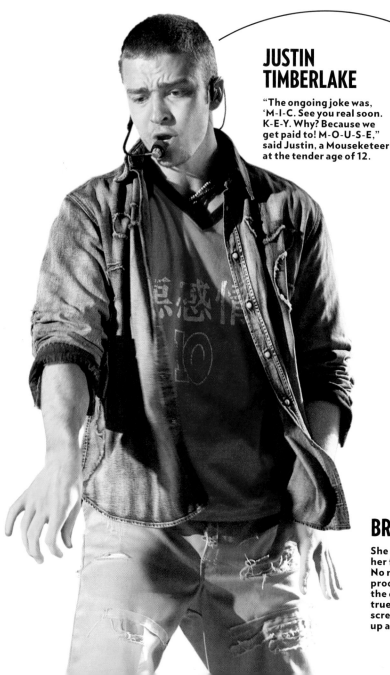

JUSTIN TIMBERLAKE

"The ongoing joke was, 'M-I-C. See you real soon. K-E-Y. Why? Because we get paid to! M-O-U-S-E," said Justin, a Mouseketeer at the tender age of 12.

BRITNEY SPEARS

She didn't make the cut on her first audition, at age 8. No matter. Two years later producers gave Spears the gig. "A dream come true," she said. "I started screaming and jumping up and down."

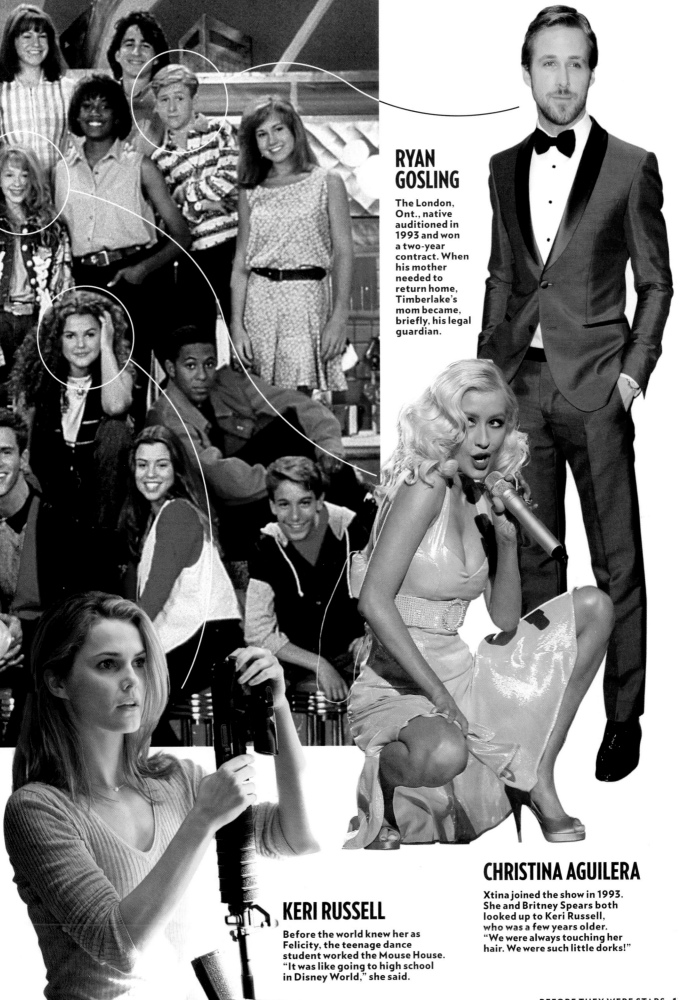

RYAN GOSLING

The London, Ont., native auditioned in 1993 and won a two-year contract. When his mother needed to return home, Timberlake's mom became, briefly, his legal guardian.

CHRISTINA AGUILERA

Xtina joined the show in 1993. She and Britney Spears both looked up to Keri Russell, who was a few years older. "We were always touching her hair. We were such little dorks!"

KERI RUSSELL

Before the world knew her as Felicity, the teenage dance student worked the Mouse House. "It was like going to high school in Disney World," she said.

FAMILY TIES

Very often in showbiz, the son—or daughter— also rises

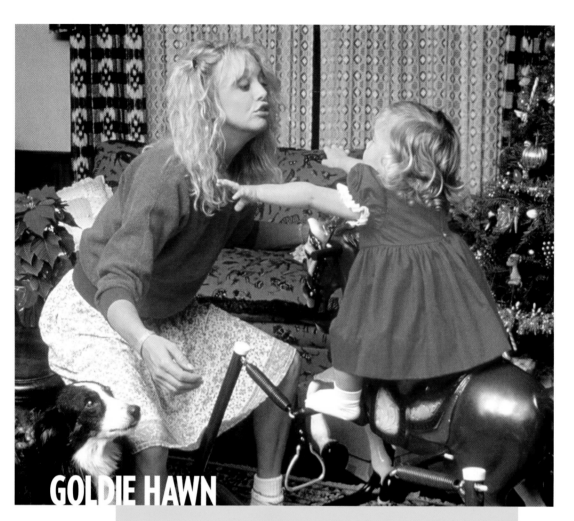

GOLDIE HAWN

KATE HUDSON

"Growing up, I thought my mom was the coolest thing on the planet," Kate Hudson once said. Mom, of course, is Academy Award–winning actress and onetime *Laugh-In* go-go dancer Goldie Hawn. But when Hudson asked if she too could be an actress— at age 11, a little too young for Goldie's taste— Hawn proved she could be uncool when necessary and said no. The answer changed as Kate matured. Today? "I would give her advice if she needed it, but I don't think I have advice to give," Hawn says. Which is fine by Hudson: Otherwise, "I don't know why I'd be paying 10 percent to my agent."

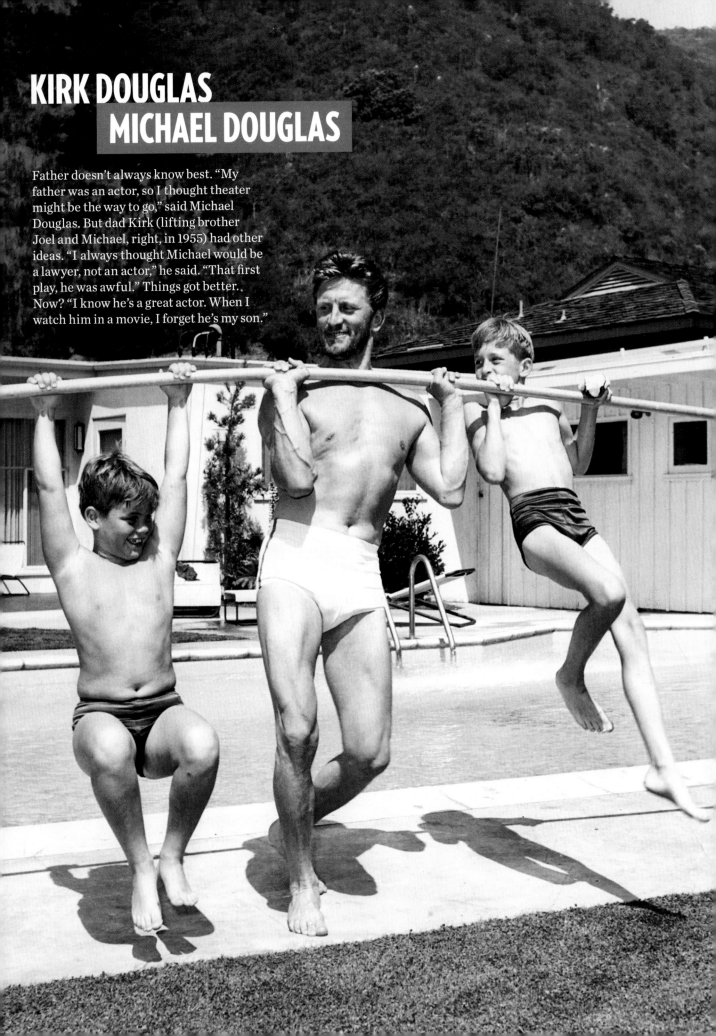

KIRK DOUGLAS
MICHAEL DOUGLAS

Father doesn't always know best. "My father was an actor, so I thought theater might be the way to go," said Michael Douglas. But dad Kirk (lifting brother Joel and Michael, right, in 1955) had other ideas. "I always thought Michael would be a lawyer, not an actor," he said. "That first play, he was awful." Things got better. Now? "I know he's a great actor. When I watch him in a movie, I forget he's my son."

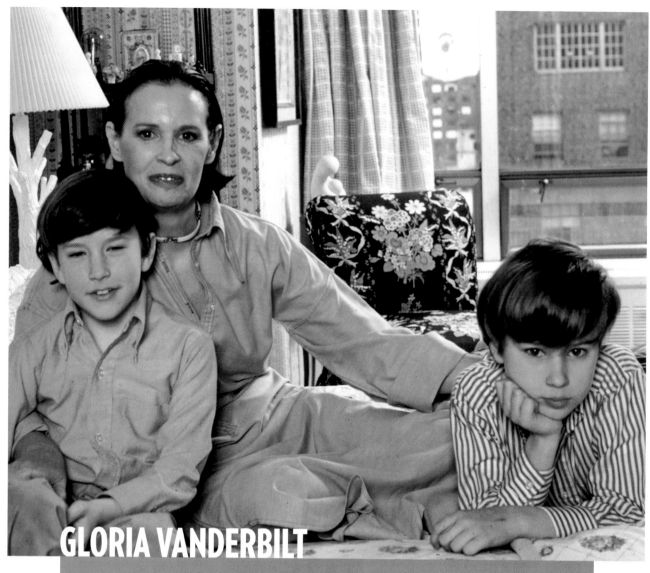

GLORIA VANDERBILT
ANDERSON COOPER

His mom has designer genes, but Anderson Cooper chose a different path. There was never a kids' table at home, so he honed his conversational skills (with guests like Andy Warhol and Charlie Chaplin) early. But it was the suicide of his brother Carter (above, right) that prepared the CNN anchor for covering wars and natural disasters. "I wanted to go to places where the pain outside would match the pain I was feeling inside," said Cooper.

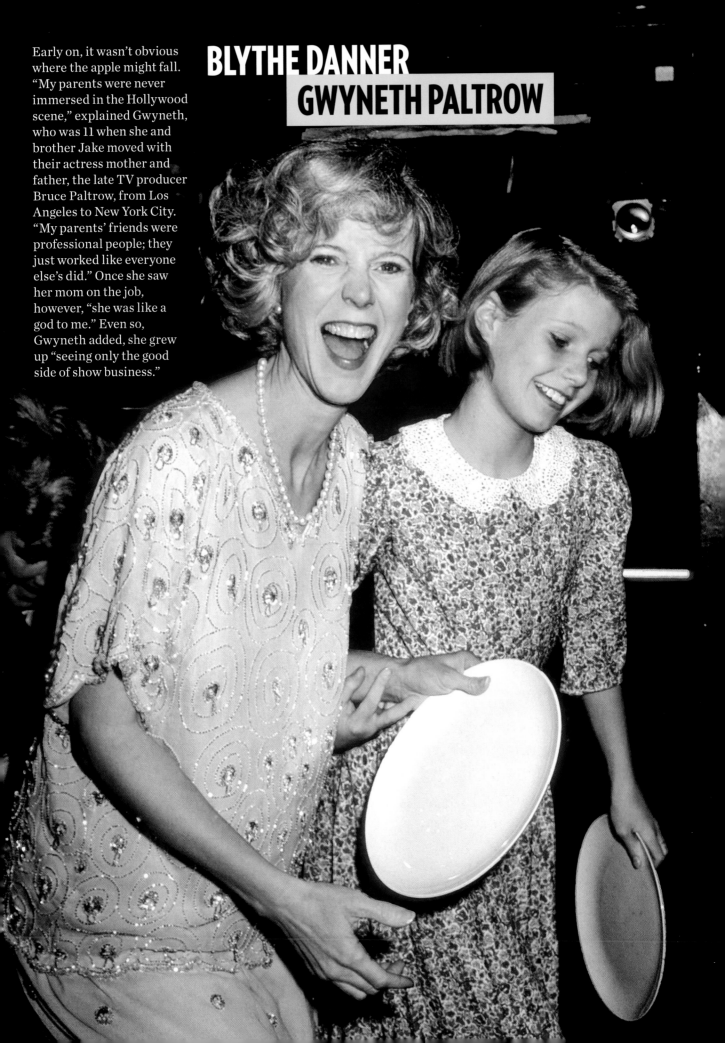

BLYTHE DANNER
GWYNETH PALTROW

Early on, it wasn't obvious where the apple might fall. "My parents were never immersed in the Hollywood scene," explained Gwyneth, who was 11 when she and brother Jake moved with their actress mother and father, the late TV producer Bruce Paltrow, from Los Angeles to New York City. "My parents' friends were professional people; they just worked like everyone else's did." Once she saw her mom on the job, however, "she was like a god to me." Even so, Gwyneth added, she grew up "seeing only the good side of show business."

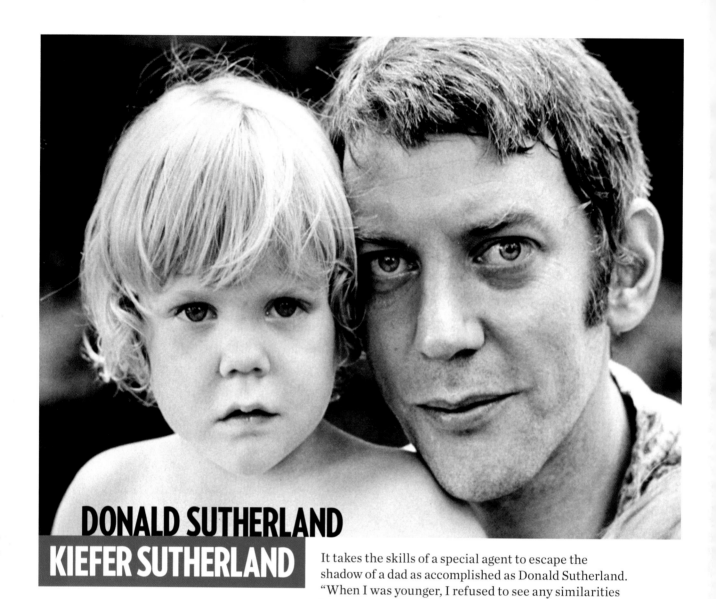

DONALD SUTHERLAND
KIEFER SUTHERLAND

It takes the skills of a special agent to escape the shadow of a dad as accomplished as Donald Sutherland. "When I was younger, I refused to see any similarities between myself and my father," Kiefer Sutherland said. "Now I see my father in me every day. I see his looks, and I see his acting style. I am my father's son."

JULIO IGLESIAS
ENRIQUE IGLESIAS

Julio Iglesias was upset when son Enrique ditched business school to sing. Now, with over 100 million albums between them, Dad admits, "He has an incredible career." The feeling is mutual. "I'm one of his biggest fans," says Enrique, "not only as a singer but as a father."

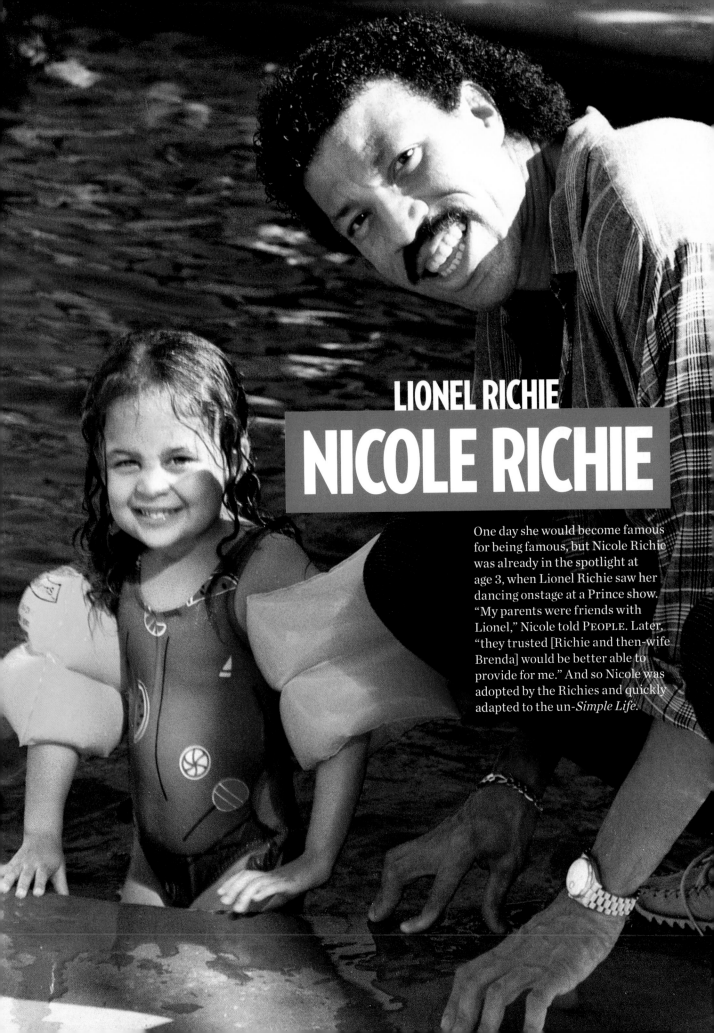

LIONEL RICHIE
NICOLE RICHIE

One day she would become famous for being famous, but Nicole Richie was already in the spotlight at age 3, when Lionel Richie saw her dancing onstage at a Prince show. "My parents were friends with Lionel," Nicole told PEOPLE. Later, "they trusted [Richie and then-wife Brenda] would be better able to provide for me." And so Nicole was adopted by the Richies and quickly adapted to the un-*Simple Life*.

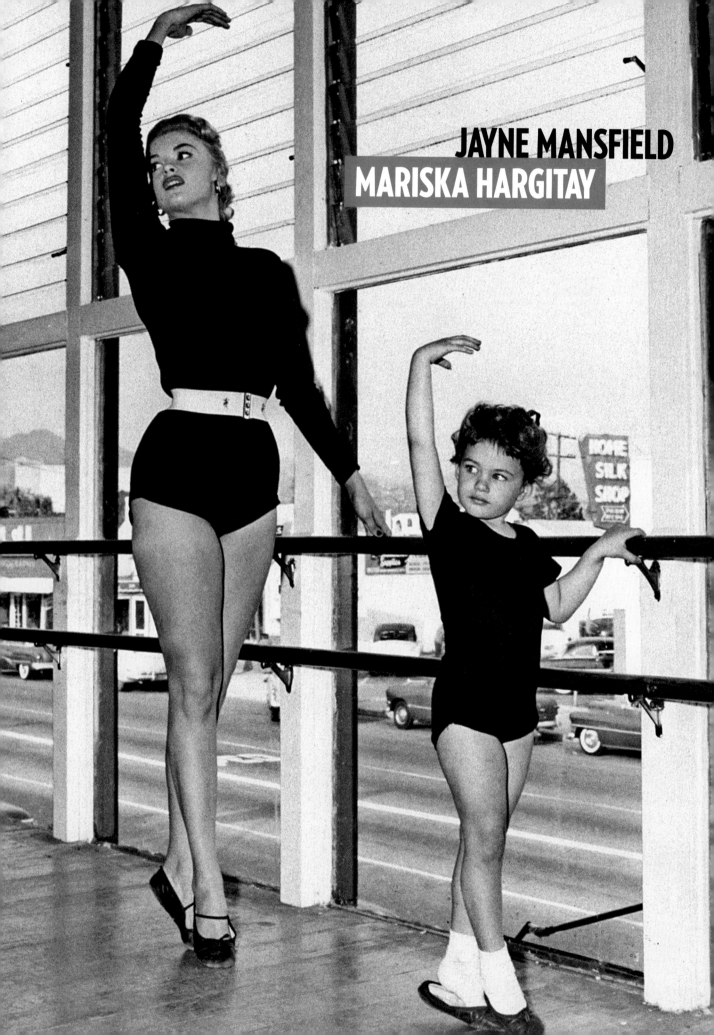

JAYNE MANSFIELD
MARISKA HARGITAY

Mariska Hargitay still remembers a LIFE magazine article touting her mother, Jayne Mansfield, as "Hollywood's Smartest Dumb Blonde." Says the *Law & Order: SVU* star: "Talk about prefeminist . . . she was a movie star, [she had] five kids, animals, a husband. She lived a very full life. Unfortunately, she didn't get to finish it." Mansfield died in a 1967 car crash at 44, and Mariska, 3, was raised by her father, Hungarian bodybuilder and onetime Mr. Universe Mickey Hargitay. In 1982 Mariska entered the Miss Beverly Hills contest on a lark and won, launching an acting career that steered away from her mother's image. "Being the daughter of a sex symbol and having people constantly compare [us], I definitely gravitated toward more tomboy roles."

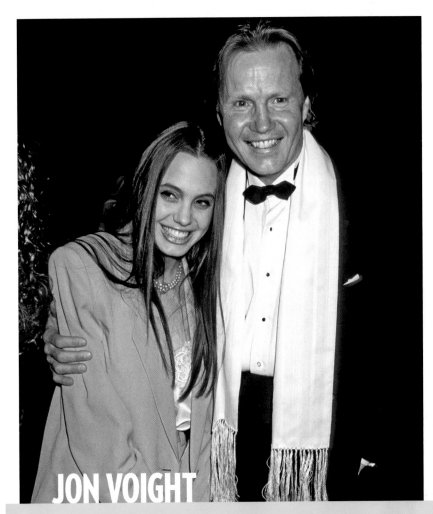

JON VOIGHT
ANGELINA JOLIE

Like many doting parents, Angelina's incessantly videotaped her early childhood. Unlike most, they trained her to emote. "Because they were artists, it was always 'Let it out' and 'Let me see what's going on inside you,'" she said of being raised by divorced actors Marcheline Bertrand and the Midnight Cowboy himself. She learned well. At 6, "she stole the scene because she was so honest and real," Voight said of her appearance in 1982's *Looking to Get Out.* Reunited onscreen 19 years later in *Lara Croft: Tomb Raider,* they played a long-estranged father and daughter. "I wanted to say a lot of those things to my dad," Angelina said of the dialogue they created together. "And he wanted to say them to me, and I wanted to hear them."

A. Clearly a young man on the move, this stylin' tyke-on-a-trike became a very big wheel.

Way, way, way before they were stars: Can you tell from the pictures who's who—or, rather, who they would grow up to be?

NAME THAT TYKE!

B. Riddle me this: The sunrise of his career began at twilight.

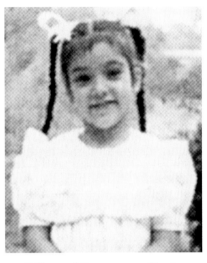

C. She would become a reality star famous for her caboose.

D. Even as a toddler, this future TV star approached life with evident glee.

E. She was always fashionable even before, as a teen, she headed for the hills.

F. Back then you could tell him anything and be sure he wouldn't gossip, girl.

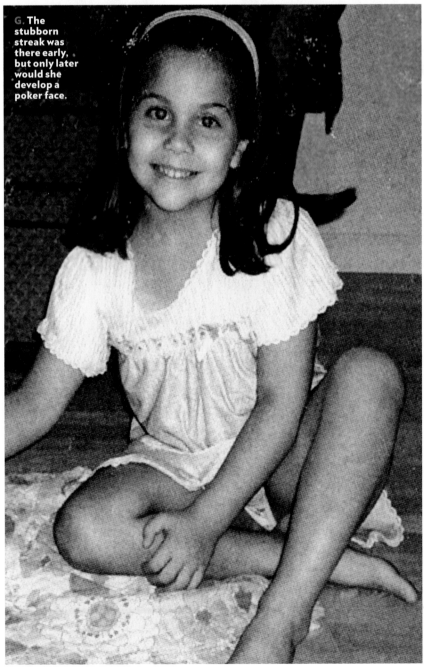

G. The stubborn streak was there early, but only later would she develop a poker face.

A. Mama mia, that little girl was already showing the world big love!

B. By 14, this baby boy had signed a record deal with producer L.A. Reid.

C. She found success as a child actress, but later her career was truly Carrie'd away.

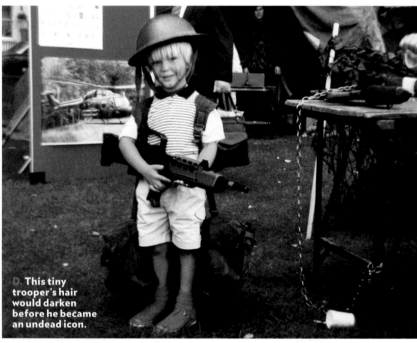

D. This tiny trooper's hair would darken before he became an undead icon.

E. Clearly, he was always happy; the Gilmore part would come later.

F. The soul of good cheer, his name is, his name is, his name is . . . Slim Baby!

G. Stylin' as a tyke, he would go on to become a notable rock of comedy.

H. A born singer-actress, she would, by high school, be very musical.

SHORE BABIES

Once upon a time the *Jersey Shore* gang had neither six-packs nor big hair

A

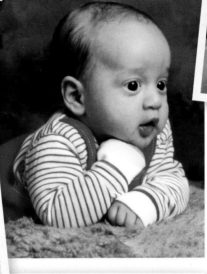
B

C

D

H

E

G

F

1. Nicole "Snooki" Polizzi

2. Paul "Pauly D" DelVecchio

3. Mike "The Situation" Sorrentino

4. Sammi "Sweetheart" Giancola

5. Deena Nicole Cortese

6. Vinny Guadagnino

7. Ronnie Ortiz-Magro

8. Jennifer "JWoww" Farley

ANSWERS: (A) Cortese (B) Giancola (C) Ortiz-Magro (D) Farley (E) Sorrentino (F) Guadagnino (G) Polizzi (H) DelVecchio

BEFORE THEY WERE STARS 143

MASTHEAD

Editor Cutler Durkee **Design Director** Andrea Dunham **Deputy Design Director** Dean Markadakis **Photo Director** Chris Dougherty **Senior Editor** Larry Sutton **Photo Editor** C. Tiffany Lee-Ramos **Designers** Phil Bratter, Margarita Mayoral, Heath Brockwell, Jorge Colombo, Joan Dorney **Cover Designer** Cynthia Rhett **Chief of Reporters** Mary Hart **Writers** Steve Dougherty, Charlotte Triggs, Laura Downey, John Perra, Ellen Shapiro, Melody Wells, Jennifer Wren **Writer-Reporters** Greg Adkins David Cobb Craig, Marisa Wong **Reporters** Deirdre Gallagher, Katy Hall, Daniel Levy, Hugh McCarten, Beth Perry, Ashley N. Williams **Copy Editors** Ben Harte (Chief), Alan Levine, Mary Radich, Tom Stephens **Production Artists** Michael Aponte, Denise Doran, Ivy Lee, Michelle Lockhart, Cynthia Miele, Daniel Neuburger, Ben Zapp **Scanners** Brien Foy, Salvador Lopez, Stephen Pabarue **Group Imaging Director** Francis Fitzgerald **Imaging Manager** Rob Roszkowski **Imaging Production Managers** Romeo Cifelli, Charles Guardino, Jeff Ingledue **Intern** Rebecca Ruiz **Special thanks:** Céline Wojtala, David Barbee, Robert Britton, Jane Bealer, Patricia Clark, Sal Covarrubias, Margery Frohlinger, Suzy Im, Charles Nelson, Ean Sheehy, Jack Styczynski, Patrick Yang

Time Home Entertainment

Publisher Richard Fraiman **Vice President, Business Development & Strategy** Steven Sandonato **Executive Director, Marketing Services** Carol Pittard **Executive Director, Retail & Special Sales** Tom Mifsud **Executive Publishing Director** Joy Butts **Director, Bookazine Development & Marketing** Laura Adam **Finance Director** Glenn Buonocore **Associate Publishing Director** Megan Pearlman **Assistant General Counsel** Helen Wan **Assistant Director, Special Sales** Ilene Schreider **Design & Prepress Manager** Anne-Michelle Gallero **Brand Manager** Michela Wilde **Associate Brand Manager** Isata Yansaneh **Associate Prepress Manager** Alex Voznesenskiy **Associate Production Manager** Kimberly Marshall **Editorial Director** Stephen Koepp **Special thanks:** Christine Austin, Katherine Barnet, Jeremy Biloon, Jim Childs, Susan Chodakiewicz, Rose Cirrincione, Lauren Hall Clark, Jacqueline Fitzgerald, Christine Font, Jenna Goldberg, Hillary Hirsch, Suzanne Janso, Amy Mangus, Robert Marasco, Amy Migliaccio, Nina Mistry, Dave Rozzelle, Adriana Tierno, Vanessa Wu

CREDITS

FRONT COVER
(clockwise from top right) Seth Poppel Yearbook Library; S. Granitz/Wireimage; Everett; Splash News; Monica Roberts; Seth Poppel Yearbook Library; Shooting Star; Courtesy Kim Kardashian; NBCU Photo Bank/AP; Rex USA; Toby Canham/Splash News

CONTENTS
2 (clockwise from left) John Paschal Celebrity Photo/Obama For America Reuters; Seth Poppel Yearbook Library; **3** Courtesy Augusta Independent HS; (insets from top) Alpha/Globe; Seth Poppel Yearbook Library; Courtesy Alicia Keys; Splash News

FIRST STEPS
6-7 John Paschal/CelebrityPhoto; **8** Seth Poppel Yearbook Library; **9** Shooting Star; **10** (clockwise from top) John Paschal/Celebrity Photo; Seth Poppel Yearbook Library; Toby Canham/Splash News; Kickapoo High School/Zuma; **11** Celebrity Photo; **12** Seth Poppel Yearbook Library(2); **13** Charles Krupa/AP; **14** James Davies/Splash News; **15** (clockwise from top) James Davies/Splash News(2); Columbia Records; **16** Lorenzo Ciniglio/Corbis; **17** Jon Kopaloff/Filmmagic; **18-19** (from left) Todd Williamson/Filmmagic; Globe; Photofest; **20** Marie Nirme/Whitehotpix/Zuma; **21** (clockwise from top right) BEImages; Dimitar Dilkoff/AP; Allfords/Splash News; Huw Evans Agency; **22** Splash News; **23** Frederic Nebinger/Abaca USA; **24** Splash News; **25** (clockwise from top) Splash News(2); NBCU Photo Bank/AP; **26-27** (top) Splash News(2); (bottom from left) E/R; Everett; Combat High: Paul Drinkwater/NBCU PhotoBank/Getty Images; Sunset Beat, BabyTalk: ABC Photo Archives/Getty Images(2); **28** Rex USA; **29** James Devaney/Wireimage; **30** Seth Poppel Yearbook Library; **31** (clockwise from top left) Seth Poppel Yearbook Library; Everett; Rex USA; **32-33** Monica Roberts; **34** Photofest; **35** Splash News; **36** (from left) Monica Roberts; Gary Boas/Retna; **37** Philip Wong/Camera Press/Redux; **38** Charlie Varley/SIPA; **39** Paulo Whitaker/Reuters; **40** Charlie Varley/

SIPA(2); **41** Everett; **42-43** Splash News; **44** Alpha/Globe; **45** (from left) Neal Preston/Corbis; Splash News; **46** Anthony Harvey/AP; **47** Roxy Rifkin/Shooting Star; **48** (from top) Jason Winslow/Splash News; Rochelle Law/Shooting Star; **49** (from top) MPTV; Snowdon/Camera Press/Redux; **50** (from top) Courtesy Kim Kardashian; FameFlynet; **51** Seth Poppel Yearbook Library

LIGHTS! CAMERA! ACTION!
54 (top) Rex USA; **55** Michael Ochs Archives/Getty Images; (inset) Everett; **56** (from left) Kobal; Marc O'Sullivan/Rex USA; **57** Splash News; (inset) Jennifer Graylock/INF; **58** (from left) Jeff Rayner/Splash News; Kobal; **59** Rex USA; (inset) Everett; **60** (from top) White & Reed/Rex USA; Kobal; **61** (clockwise from top left) Rex USA; CBS/Landov; ABC Photo Archives/Getty Images; Kobal; **62** Courtesy Eric Stonestreet; Ron Tom/ABC; **63** Seth Poppel Yearbook Library; (inset) Kobal; **64** (from left) Seth Poppel Yearbook Library; Brian Doben; **65** Courtesy Jack McBrayer; (inset) Mary Ellen Matthews/NBCU; **66** (clockwise from top left) Richard Beetham/Splash News; Photofest; Seth Poppel Yearbook Library; Kobal; **67** Seth Poppel Yearbook Library; (inset) Everett

STRIKE A POSE!
72-73 (from left) Heidi Schumann/Polaris; Heath Family/AP Wide World; **74** Stuart Campbell/Austral/Zuma; **75** Alan Nakamura/Zuma; **76-77** Brad Elterman/Zuma; **78** Michael Paris/Shooting Star; **79** S. Granitz/Wireimage; **80** Lennon/Shooting Star; **81** Diana Whitley/Shooting Star; **82-85** All Photos: Jade Albert

CELEBRITY HIGH YEARBOOK
88-89 Washington: Globe; Clooney: Courtesy Augusta Independent High School; All Other Photos: Seth Poppel Yearbook Library; **90-91** Anderson: Vanegas-Barrand/Shooting Star; Berry: Bedford High School/Zuma; All Other Photos: Seth Poppel Yearbook Library; **92-93** Chesney: Splash News; All Other Photos: Seth Poppel Yearbook Library; **94-95** Damon: Boston Herald/Rex USA;

Poehler: Splash News; All Other Photos: Seth Poppel Yearbook Library; **96-97** All Photos: Seth Poppel Yearbook Library; **98-99** Longoria: Roy Miller High School/Zuma; All Other Photos: Seth Poppel Yearbook Library; **100-101** McAdams: Splash News; Knightley: Rex USA; All Other Photos: Seth Poppel Yearbook Library; **102-103** Underwood: Courtesy Carrie Underwood; All Other Photos: Seth Poppel Yearbook Library

I WAS A TEENAGE DRAMA GEEK
104 (clockwise from top left) Courtesy Stagedoor; Abaca USA; Seth Poppel Yearbook Library; **105** (clockwise from top left) Seth Poppel Yearbook Library; Courtesy Zach Braff; Seth Poppel Yearbook Library; Alan Macdonald/Camera Press/Redux

CHEERLEADERS
106-107 Lohan: Phil Penman/Splash News; All Others: Seth Poppel Yearbook Library

GO TEAM!
108 (clockwise from top left) Splash News; Vanegas-Barrand/Shooting Star; Splash News; Seth Poppel Yearbook Library; **109** (clockwise from top left) Seth Poppel Yearbook Library(3); Globe; Charlie Varley/SIPA

BEFORE THEY WERE GLEEKS!
110-111 Riley: Courtesy Amber Riley; Michele: Catherine Ashmore; All Other Photos: Seth Poppel Yearbook Library

POLLS & PUNDITS
112-113 All Photos: Seth Poppel Yearbook Library

I WANNA ROCK WITH YOU
116 Courtesy Beyoncé Knowles; **117** Toby Canham/Splash News; **118** (from left) Seth Poppel Yearbook Library; Splash News; **119** Courtesy Alicia Keys; **120-121** (top) Newspix/Rex USA; (bottom photos) TalkbackThames/Rex USA; **122-123** Courtesy Clay Aiken

TINY AND TALENTED
124 (from left) Universal; Martin Grimes/

Splash News; **125** (from top) Splash News; Lucy Nicholson/Reuters; **126** (clockwise from left) Frank Micelotta/PictureGroup; Splash News; MPTV; Splash News; **127** (from top) Rondeau/Presse Sports/Abaca USA; Linda Armstrong Kelly/Sports Illustrated Pictures/Getty Images

I'M WITH THE MOUSE
128-129 (clockwise from top right) Joseph Kerlakian/Rex USA; Kevin Winter/Getty Images; Everett; Kevin Kane/Wireimage; Dennis Clark/Getty Images; Photofest

FAMILY TIES
130-131 (framed photos, clockwise from top) Jeff Rayner/Splash News; Ron Wolfson/Retna; Splash News; Phil Roach/Ipol/Globe; Michael Jacobs/Zuma; **132** Steve Schapiro; **133** Hulton Archive/Getty Images; **134** Susan Wood/Hulton Archive/Getty Images; **135** Ron Galella/Wireimage; **136** (from top) Co Rentmeester/Time Life Pictures/Getty Images; Alvaro Rodriguez/Corbis Sygma; **137** Ron Wolfson/Wireimage; **138** Snap/Zuma; **139** Jim Smeal/Wireimage

NAME THAT BABY!
140 Obama For America/Reuters; **141** All Photos: Seth Poppel Yearbook Library; **142** (clockwise from top left) Graeme Massie/Splash News; Courtesy Usher; Malibu Media; Seth Poppel Yearbook Library(2); Splash News; Charlie Varley/Sipa; Splash News; **143** All baby photos courtesy of subject; (current head shots, clockwise from top left) Jason Merritt/Getty Images; Jesse Grant/Wireimage; Craig Barritt/Wireimage; Larry Busacca/Getty Images; Charles Sykes/AP; Ethan Miller/Getty Images; Allpix/Splash News; Chelsea Lauren/Wireimage

SECTION OPENERS
Photography By Michael Lewis

BACK COVER
(clockwise from top left) Jade Albert; Seth Poppel Yearbook Library(2); James Davies/Splash News; Splash News; Michael Paris/Shooting Star; Seth Poppel Yearbook Library; Courtesy Alicia Keys